IMAGES
of Rail

RAILS AROUND
DURANGO

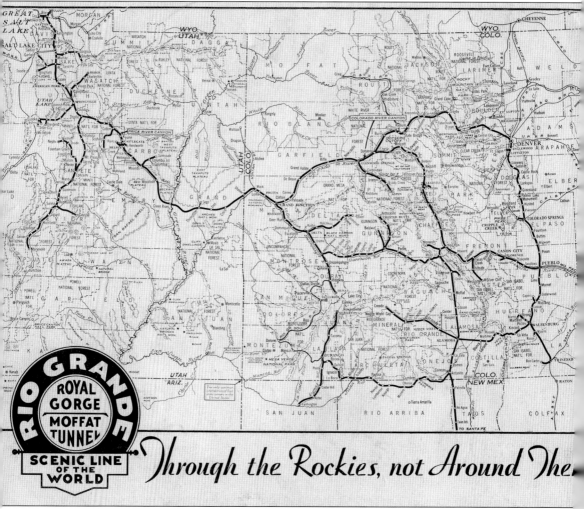

RIO GRANDE
ROYAL
GORGE
MOFFAT
TUNNEL

SCENIC LINE
OF THE
WORLD

Through the Rockies, not Around Them

This map from the late 1930s shows the complete system of the Denver & Rio Grande Western, which stretched from Colorado into Utah. At this time, many of the railroad's narrow-gauge branches were still in place, including the line between Durango and Silverton.

ON THE COVER: Durango was a major junction point on the narrow-gauge system and a place where inbound and outbound trains were de-consolidated and assembled. This photograph shows Caboose No. 0505 and a Rio Grande brakeman stepping into his "office" while helping to break down a recently arrived freight train.

IMAGES
of Rail

RAILS AROUND
DURANGO

Allan C. Lewis

ARCADIA
PUBLISHING

Published by Arcadia Publishing
Charleston SC, Chicago IL, Portsmouth NH, San Francisco CA

Printed in the United States of America

Library of Congress Catalog Card Number: 2006926131

For all general information contact Arcadia Publishing at:
Telephone 843-853-2070
Fax 843-853-0044
E-mail sales@arcadiapublishing.com
For customer service and orders:
Toll-Free 1-888-313-2665

Visit us on the Internet at www.arcadiapublishing.com

This book is dedicated to my friend Bill Knous (1951–2006). His friendship was a blessing and his dedication to preserving railroad history has touched the lives of many rail fans. He is greatly missed. (Photograph by David Tackett.)

CONTENTS

ACKNOWLEDGMENTS

The photographs, ephemera, and artifacts that illustrate this book have been selected from the author's archives. While the assembly of these images was the sole effort of the author, this book would not have been possible without the photographic talents of Lad Arend, Alfred Jaeger, Ernie Peyton, William H. Jackson, Frank O. Kelly, B. F. Gurnsey, Whitman Cross, James Osborn, Joseph Schick, James Bowie, W. O. Gibson, Roland Parsons, George Schlaepfer, Doug Summers, and David Tackett. I am also grateful to Doug Summers and Steve Rasmussen for their technical support. Assistance also came from my family. I am deeply indebted to my wife, Pam, who allowed me the time required to bring this project to fruition, and my son Joey whose interest in Colorado narrow-gauge railroading has served to further my own. I would also like to acknowledge my friend, the late Bill Knous, for whom this book is dedicated.

The nostalgia of railroading can be enjoyed by rail fans of any age. As long as there are old railroaders with a story to tell and children willing to listen, the history of the narrow gauge will always be preserved.

INTRODUCTION

In the early 1880s, few places were more inviting to an expanding railroad than the mineral-rich mining areas of Colorado's San Juan Mountains. When the narrow-gauge Denver and Rio Grande reached the Animas Valley in 1881, the railroad became the catalyst for regional growth. Here the communities of Durango and Animas City were established along with a railroad depot, roundhouse, and other facilities. This new rail connection afforded the budding community a more economical means of transportation, and as the railroad grew, so did Durango.

Building a railroad to Durango was only a start as the Denver and Rio Grande continued its construction up the Animas River to Silverton. The Rio Grande's arrival in Silverton stimulated growth in the surrounding communities during the 1880s. However the devaluation of silver during the 1890s and the turbulent economy that followed would have a far-reaching impact on local mining activities. While ore shipments would continue to flow over the next 60 years, the volumes would rise and fall in a reflection of the changing economy. The new century did not bring any additional promise to Silverton and its neighboring mine, and the three narrow-gauge railroads that supported them slowly started to disappear. Through World War I, and then the Great Depression, the area struggled.

By the 1940s, the general decline in freight activity was being felt across the narrow gauge and there was little money allocated to maintain these lines. Focusing on its role as a bridge line, the Denver & Rio Grande Western Railroad channeled most of its attention and its investments on standard-gauge operations. However despite dwindling volumes, mixed freight service continued between Durango and Silverton. While rail fans began to discover Durango after the war, the future of its narrow gauge remained in doubt.

The railroad's neglect of the narrow gauge carried over into the 1950s, but tourists continued to arrive in ever-increasing numbers. With cameras in one hand and tickets in the other, passengers filled the coffers of the Rio Grande and helped to keep the scrapper's torch at bay. Even Hollywood got word of the Silverton Branch, which became the setting for several movies, including the 1951 epic *Denver and Rio Grande*. Although the future was improving for passenger service between Durango and Silverton, the 1950s took a toll on the Rio Grande's once vast narrow-gauge empire. The run up the Animas River was now called *The Silverton*, a far cry from the mixed train of a decade before. In an effort to accommodate the influx of passengers as tourism started to become an industry, trains out of Durango were now longer. Although brief in its duration, freight traffic increased during this time as the Rio Grande responded to the oil and natural-gas boom that was occurring around Farmington, New Mexico.

For Durango, the 1960s would bring major changes to local commerce. Although narrow-gauge engines still steamed along the Animas, the Farmington freight boom began to dry up. The end of this traffic sealed the fate of freight operations and hastened the scrapping of the Farmington Branch, as well as the tracks between Durango and Chama. Once these lines were abandoned, the Rio Grande found itself operating *The Silverton* throughout the 1970s without a rail connection to the outside world.

Public support once saved *The Silverton* from being consigned to history and it would do so again. During the next two decades, rail fans continued their pilgrimages to Durango in record numbers. With the coaches, the heroic branch line continued to earn its keep. However for many

years, the D&RGW wanted to get out of the tourist business and finally did so when the line between Durango and Silverton was purchased by John Bradshaw Jr. in 1981. Bradshaw brought new life to the railroad and a new name. The Durango and Silverton Narrow Gauge Railroad soon had an upgraded right-of-way and an expanded equipment roster. These improvements enabled larger equipment to be used on the right-of-way, which facilitated the addition of longer trains with larger revenues.

Upgrades on the D&SNG continued in the 1990s and, in 1997, the railroad was acquired by Florida real estate developer Allen Harper. Since that time, the railroad has become even more focused on preserving history and the interests of rail fans. Once static equipment has been restored to operating condition, and events like Railfest beckon rail fans from around the globe. For 125 years, Durango and Silverton have been connected by a narrow-gauge railroad. Today the future looks bright for the D&SNG thanks in part to the dedication of the men and women who run the railroad and the enthusiasm of those who ride it.

The nostalgia of narrow-gauge trains is something families have been experiencing together for several generations. While waiting on the "Eureka" at Rockwood, the author's son Joey leaves little doubt as to his favorite railroad—he's pointing to the Rio Grande herald on a flat car. (Photograph by Allan C. Lewis.)

One

Durango Gets
a Railroad

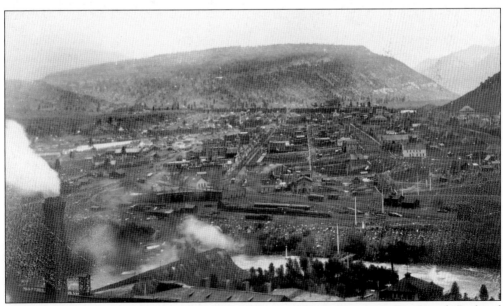

From its initial construction into the Animas Valley in 1881, the Denver & Rio Grande Railroad played a vital role in the development of Durango. This early view, taken from the heights above the San Juan Smelter, shows the D&RG's depot, yards, and roundhouse.

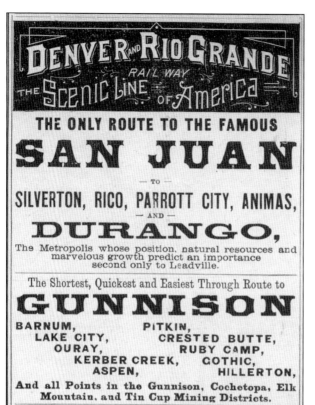

THE ONLY ROUTE TO THE FAMOUS
SAN JUAN
— TO —
SILVERTON, RICO, PARROTT CITY, ANIMAS,
— AND —
DURANGO,
The Metropolis whose position, natural resources and marvelous growth predict an importance second only to Leadville.

The Shortest, Quickest and Easiest Through Route to
GUNNISON
BARNUM, PITKIN,
LAKE CITY, CRESTED BUTTE,
OURAY, RUBY CAMP,
KERBER CREEK, GOTHIC,
ASPEN, HILLERTON,
And all Points in the Gunnison, Cochetopa, Elk Mountain, and Tin Cup Mining Districts.

In this 1884 advertisement, the D&RG predicts the mining potential of Durango as being only second to that of Leadville. The railroad also touts some of the newer camps, including the failed community of nearby Parrot City.

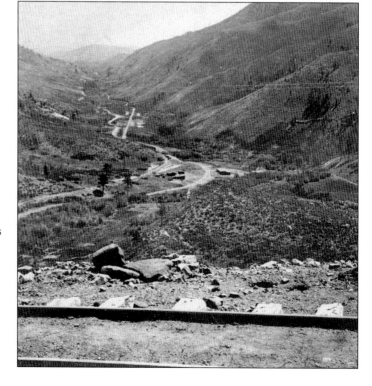

The expanding Rio Grande reached the San Juans via the San Luis Valley and the conquering of La Veta Pass. This early photograph looks east from La Veta along the expanding tracks of the D&RG and the community of Ojo. (Photograph by B. F. Gurnsey.)

Despite the difficulties of building a railroad along the rocky terrain of the Animas River, the D&RG completed the line from Durango to Silverton in only one year. One of the most challenging portions of this construction was the track between Rockwood and Tacoma, which became known as the "High Line."

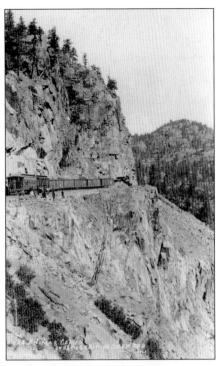

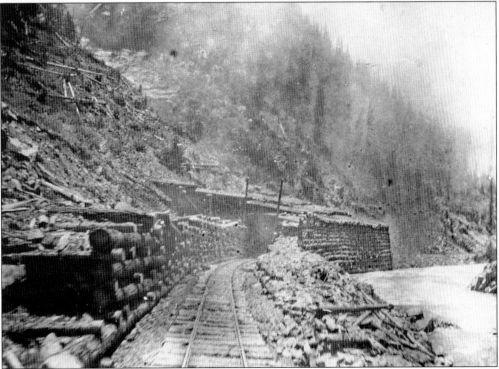

Building a railroad along the Animas River often meant the narrow-gauge right-of-way was threatened by rising water levels. This photograph shows one of the water barriers near Silverton built to protect the tracks.

By 1888, when this timetable was issued, the D&RG provided three trains daily between Alamosa and Chama to Durango and a fourth between Durango and Silverton. At this time, the *Silverton Accommodation* made the 45-mile connection in a little over four hours.

The rails in and out of Durango not only provided the link between the mines and smelters, they hauled passengers as well. This photograph was taken of a Denver-bound Durango family waiting on the next train to Alamosa.

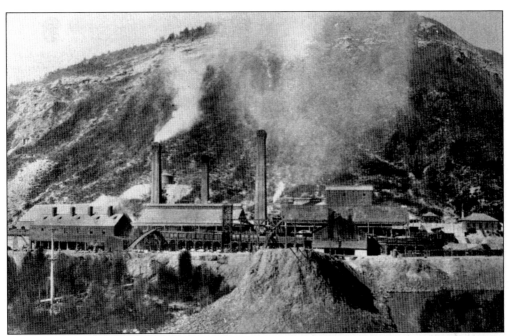

The American Smelting and Reduction Company was one of several smelters established in the Durango area. This facility was located across the Animas River from the D&RG yards, and its familiar stack appears in many local railroad photographs. (Boston Photograph.)

This receipt is from an ore shipment brought in by the Rio Grande Southern, or RGS, from Pandora. The American Smelting and refining plant at Durango received ore from both the Denver & Rio Grande and the Rio Grande Southern.

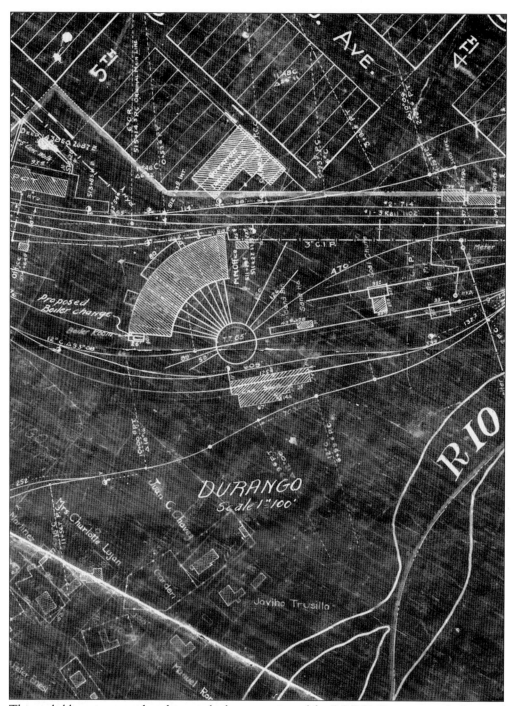

This early blueprint provides a historic look at a portion of the D&RG's Durango yards. Pictured here are the roundhouse, depot and offices, coaling facility, and the property of the Durango Iron Works.

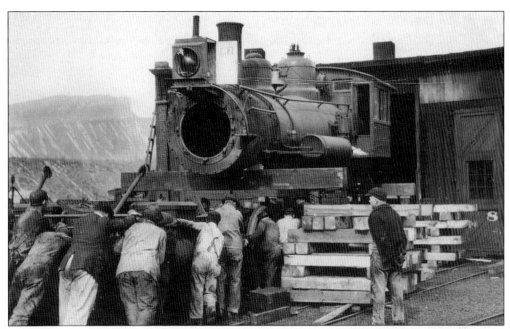

Durango was an integral part of freight and passenger operations and a service point for cars and engines. This view shows a group of roundhouse workers during a major maintenance overhaul on a Baldwin locomotive.

In the early 1900s, Charlie Spencer worked for D&RG in several capacities. At one time, he worked in the car shops and later as a telegraph operator.

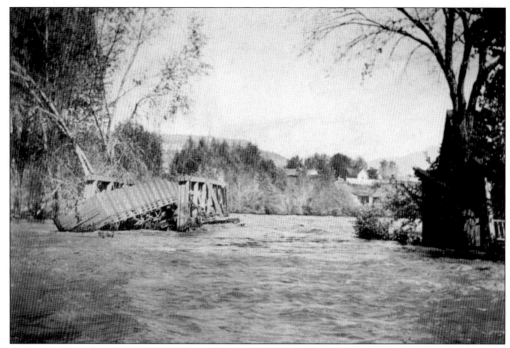

A flood along the Animas River in 1911 wreaked havoc on both the railroad and the town of Durango. Along the right-of-way, the D&RG parked loaded gondolas on nearby bridges in an attempt to keep the bridges from washing away. As this photograph demonstrates, those efforts failed.

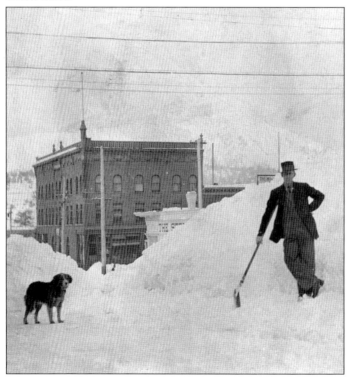

San Juan snows created many problems along the Silverton Branch, but it also affected the citizens of Durango. This photograph, taken near the intersection of Main and Sixth Streets, shows a resident and his dog digging out after a recent storm.

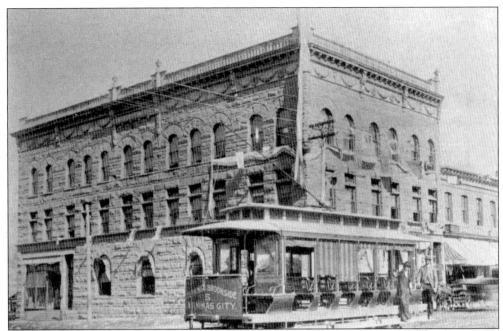

By the 1890s, Durango was one of the largest industrialized centers in southwest Colorado and worthy of a public transportation system. Trolley Car No. 5, of the Durango Railway and Realty Company, shuttled Durango citizens between the D&RG depot and the "suburb" of Animas City.

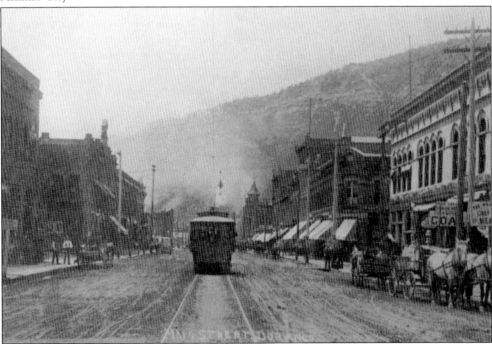

Durango's Main Street was the hub of regional activity where residents gathered to conduct business and do their shopping. When this photograph was taken near the intersection of Main and Ninth Street, the horse, wagon, and trolley still dominated local transportation.

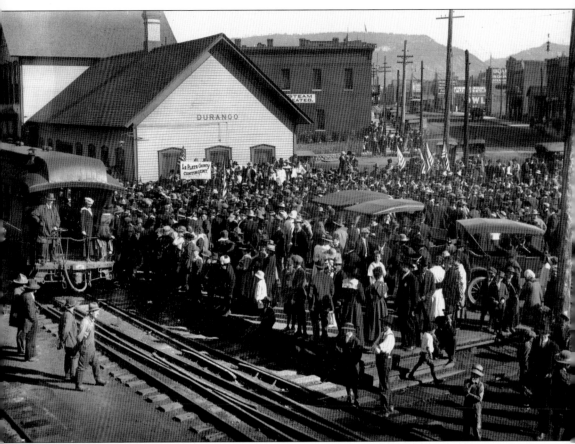

The Durango depot was a popular gathering place for celebrations, as this 1918 scene demonstrates. The sign reading "La Plata County Contingent" indicates a political rally or perhaps draftees heading off to fight in World War I. This rare image also shows the third rail added for the Farmington Branch.

Engine No. 174 was one of the D&RG's Class T-12 "10-Wheelers." This locomotive was built in 1884 and served many years on the Alamosa–Durango passenger runs.

Engine No. 175 was a sister to No. 174 and worked in passenger service on the San Juan Extension. This photograph was taken near the Durango coaling dock about 1924.

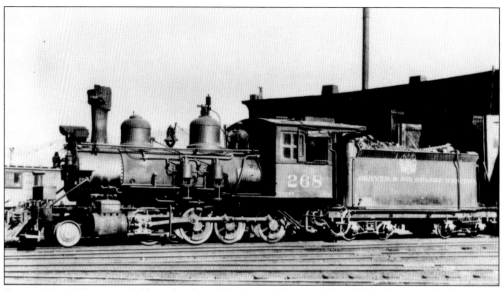

Engine No. 268 was a Baldwin-built 2-8-0 Consolidation. This 1938 photograph shows the locomotive in its basic black paint, but a decade later, it would wear the famous "bumblebee" paint scheme.

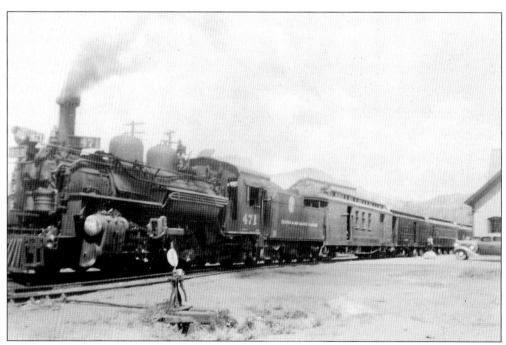

No. 471 was another Class K-28 Engine that worked the narrow gauge. This photograph shows 2-8-2 No. 471 in front of the Durango depot at the head of the *San Juan*. Like some of the other engines in its class, No. 471 would later see service on Alaska's White Pass and Yukon Route.

Two

SILVERTON AND ITS SURROUNDINGS

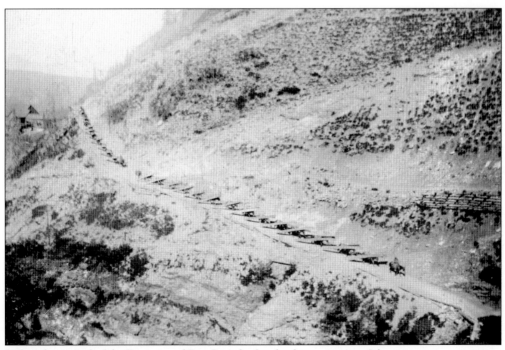

Before the arrival of the Denver and Rio Grande, freight shipments into Silverton were reminiscent of this photograph. Stage roads and toe paths were the main supply routes, and supplies were often freighted in by wagon or in long animal caravans like this one.

In the 1880s, David Wood billed the San Juan Stage Lines as the "largest freighting outfit in the west." However 10 years later, many of the points that were once only accessible by wagon were now being served by the D&RG and the Rio Grande Southern.

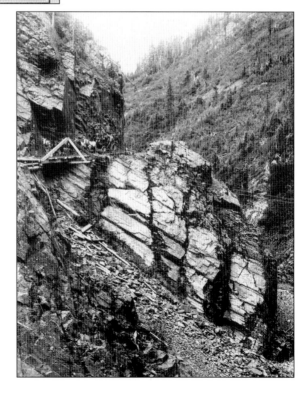

This photograph shows a stagecoach on a precarious portion of the Ouray-Red Mountain Toll Road and is indicative of early travel to and from the Silverton and the surrounding communities. The rough ride in a Concord coach made the trip a bumpy one and the advent of the railroads a welcome sight.

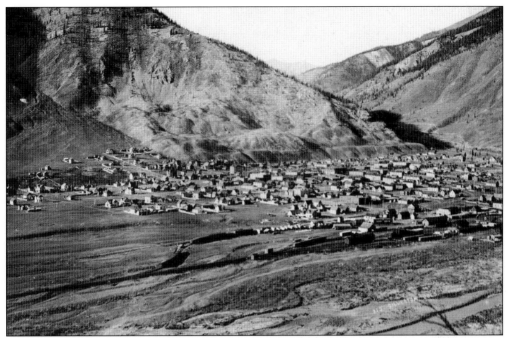

The early success of Silverton was predicated on local mining interests, and as the mines grew so did the town. This panoramic view shows several Silverton landmarks, including the Silverton School, the Grand Imperial Hotel, and in the bottom right corner, a busy scene in the railroad yards.

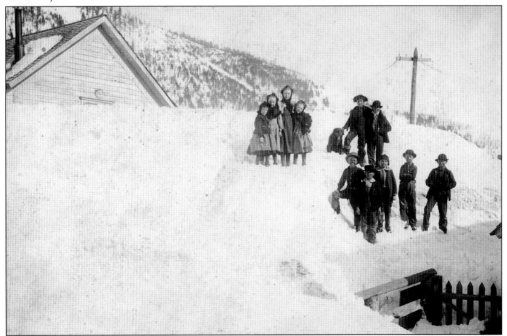

No school today! The snows in Silverton became legendary and made hearty residents out of the local population. Huge snow accumulations like this one were a great hardship to local businesses and the railroads but an opportunity for area children to play in the snow.

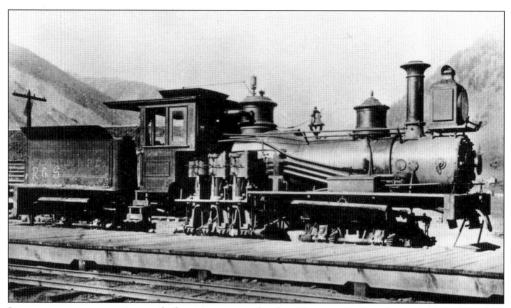

In an attempt to tame its nearly five-percent grade, the Silverton Railroad acquired the No. 269, a two-truck geared locomotive of the Shay design built by the Lima Locomotive Company in 1890. Dubbed the "Guston," the slow-moving engine was in the process of being transferred to the Rio Grande Southern when this photograph was taken in 1893.

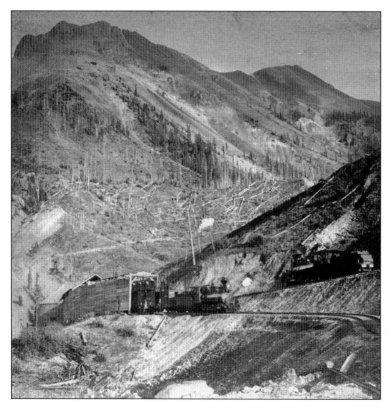

One of the greatest anomalies in railroad history was the covered turntable, located at Corkscrew Gulch. The turntable was unique in that it was built directly into the main line of the narrow gauge. In this photograph, a leased D&RG waits up hill from the covered turntable while Silverton Railroad 2-8-0 No. 100, the "Ouray," with a D&RG box car and the combine Red Mountain, head down grade to Ironton. (Photograph by William H. Jackson.)

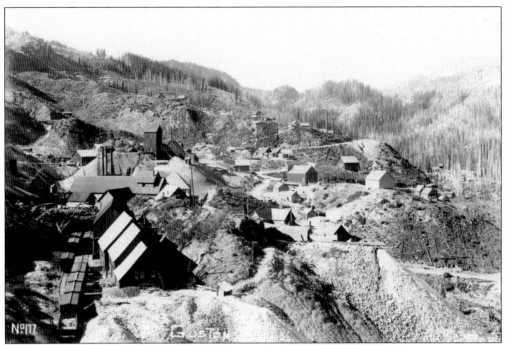

This photograph shows a group of boxcars and a gondola on the Silverton Railroad's Guston–Robinson siding. The town of Guston sprang up around the Guston Mine and the properties originally established by John Robinson in 1881.

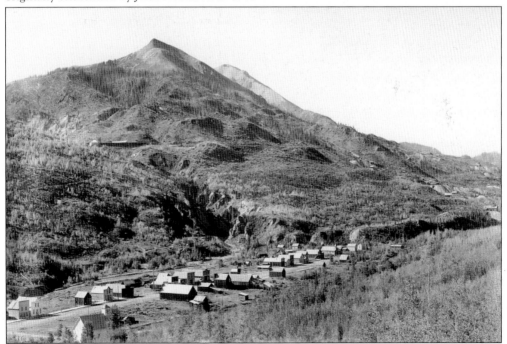

Initially the Red Mountain Mining District had few schools and ever fewer churches. The town of Ironton had both; the church is pictured in the lower left foreground and a school to the right at the other end of Main Street. (Photograph by Whitman Cross.)

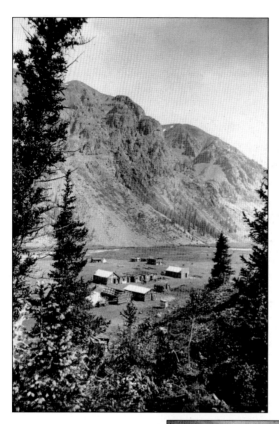

While this 1875 view shows Howardsville in its infancy, the town would grow and would later be served by the Silverton Northern Railroad. The town was named after George Howard, who had built a cabin along the Animas River near Cunningham Gulch. (Photograph by William H. Jackson.)

Some of the more profitable but isolated properties around Silverton were served by aerial tramways, not railroads, but regardless of the transportation mode, winter affected each the same. This 1900s photograph shows a miner in front of an ice-encrusted tramway tower near Gladstone.

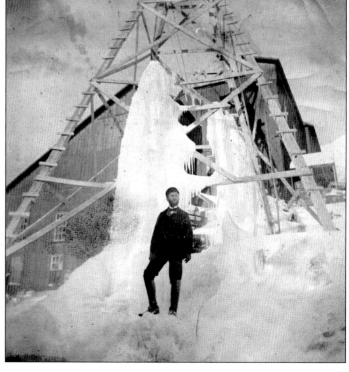

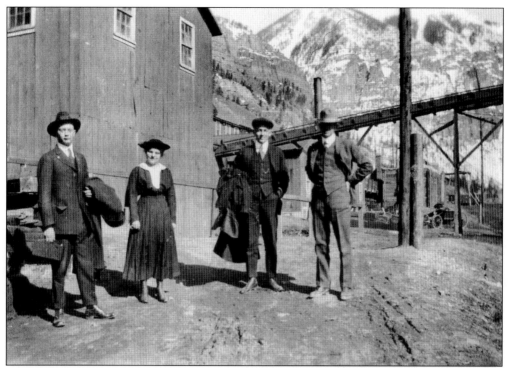

In 1915, the Sunnyside Mill was shipping zinc to help the war efforts of the Triple Entente; three years later, it was sending its employees. Despite the remote locations of the communities around Silverton, they were still within the grasp of Uncle Sam. With bags packed and coats in hand, these two future members of the 89th Infantry Division will soon board a D&RG train on the first leg of their world-war journey.

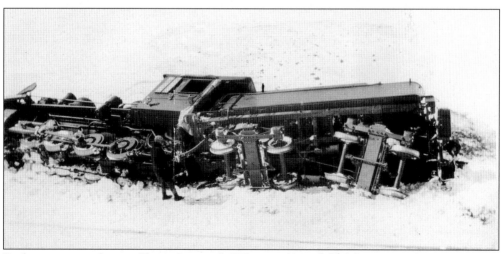

Bucking snow was long and hazardous work. When ice formed thick layers over the narrow-gauge tracks, it could easily derail an engine and send it tumbling off the right-of-way. Such a fate occurred to this unknown engine while clearing snow in the Silverton area in the 1920s.

Silverton Northern No. 3 is pictured here poking its head out of the engine house in preparation for another trip to Silverton. In 1943, the "three spot" was sent to Alaska where it served the White Pass and Yukon Railway. (Photograph by James Osborn.)

Although not as substantial as the Rio Grande station down the street, the Silverton Railroad also had a depot in Silverton. This is how the boarded-up structure at the corner of Tenth and Cement Streets appeared after the line's abandonment. (Photograph by Joseph Schick.)

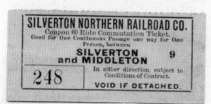

Commutation tickets were a more affordable way for passengers to purchase fares when traveling to specific points on a regular basis. The Silverton Northern offered these tickets to miners, engineers, merchants, and other travelers who frequently rode the rails between Silverton and Animas Forks.

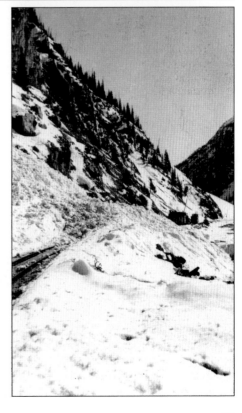

By the 1920s, the Denver and Rio Grande had been reorganized as the Denver & Rio Grande Western. Despite the change in name, winter operations along the railroad would remain just as challenging. This scene, taken below Silverton, shows the results of a recent avalanche and the D&RGW crew tasked with clearing the line. (Photograph by M. R. Henry.)

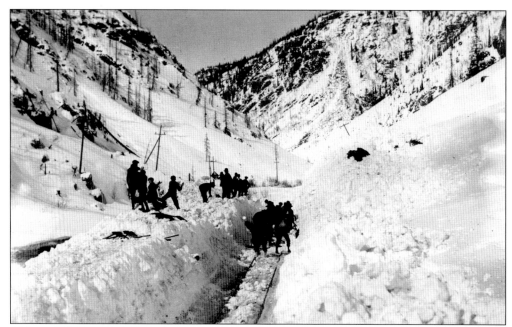

Although the Rio Grande had several narrow-gauge rotary snowplows, they were often assigned to the more frequently used lines. As a result, when snowslides occurred along the Animas River, workers often had the arduous task of clearing the line by hand.

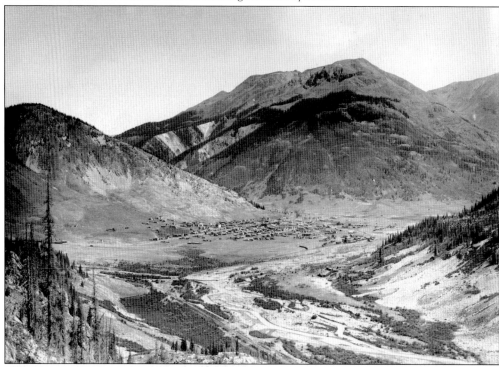

This photograph was taken in 1900 from high above the town of Silverton. The Rio Grande depot and yards are to the right along with the two-stall D&RG engine house. (Photograph by Whitman Cross.)

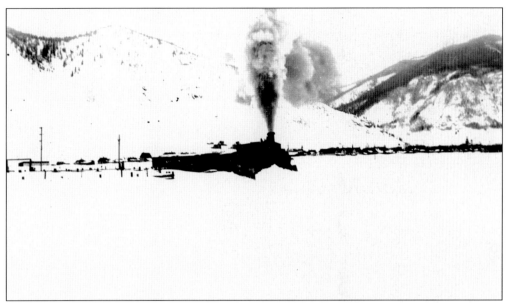

By 1946, World War II had ended, the last of the "Three Little Lines" was gone, and the D&RGW reigned supreme over what freight activity remained in Silverton. This scene shows a plow-laden Rio Grande engine and caboose about to leave Silverton followed by a string of boxcars. (Photograph by James Bowie.)

Although narrow-gauge enthusiasts would descend upon the Rio Grande in droves in the late 1940s, they were not a common sight in the early 1930s. With camera bellows extended, this Depression-era rail fan sits on a Silverton cattle guard waiting for the next train.

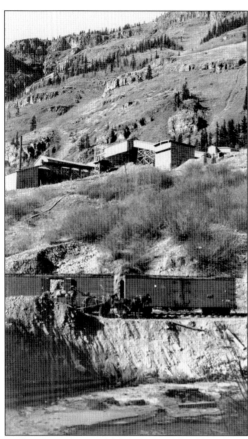

The Sunnyside Mine proved to be one of the last major shippers in the Silverton area. This view shows a pair of D&RGW reefers being loaded from a horse-driven ore wagon.

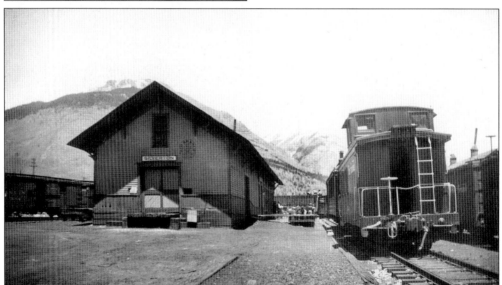

Taken during the mid-1940s, this photograph shows Caboose No. 0540 and D&RGW combine at the Silverton depot. In the background, a group has gathered to watch the loading of a stock car. At this time, the old "Royal Gorge Route" logo still appeared on the south end of the depot. (Photograph by Lad Arend.)

Three

FROM TARIFFS TO TOURISTS

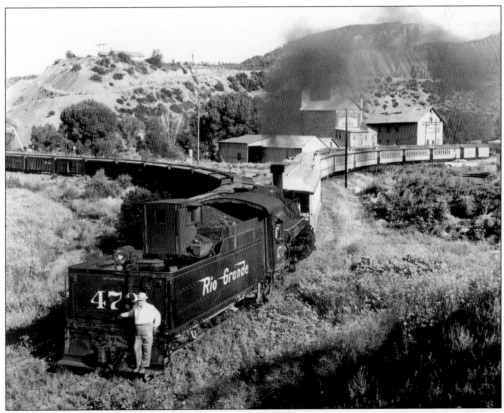

Although taken in 1961, this photograph was indicative of area operations from the 1940s through the late 1960s. The scene shows Engine No. 473 pushing a string of passengers near the Durango depot while a freight train waits for attention. (Photograph by Alfred Jaeger.)

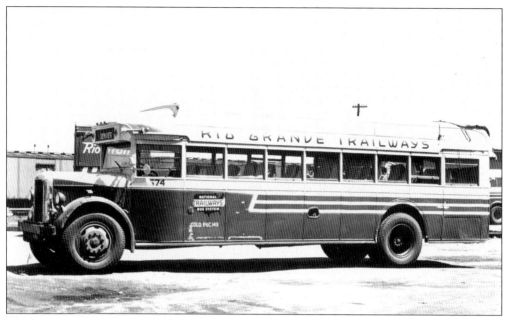

The Rio Grande established its own truck and bus lines in answer to the increasing automobile traffic that started to threaten rail-passenger operations. Buses like this one were operated by the Rio Grande Motorway and served some of the more isolated communities that had either no rail connection or just freight service.

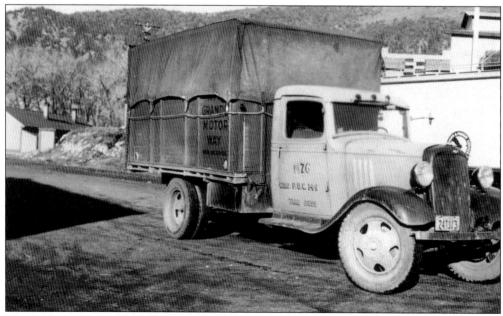

The road equipment of the Rio Grande Motorway was not just limited to buses. The company also had a fleet of trucks that provided volume and less-than-truckload service along the line.

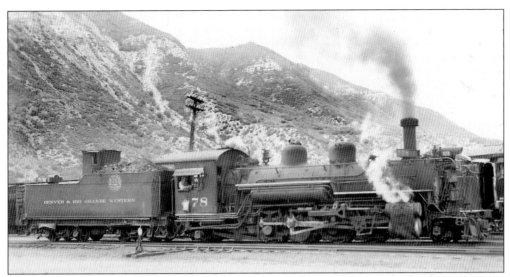

This 1940 shot of Engine No. 478 was taken in the Durango yards as it paused before heading north to Silverton. Built by the Baldwin Locomotive Company in 1923, the engine was one of the Class K-28 locomotives with a tractive effort of 27,540 pounds.

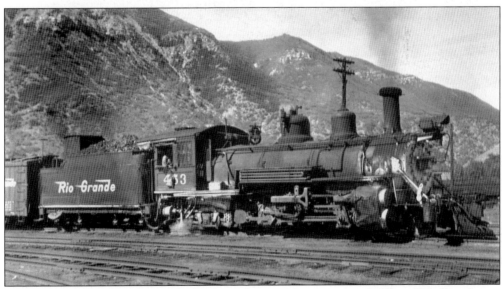

Engine No. 453 is pictured near the Durango depot ready to go to work. These "Mudhens" were a favorite with Rio Grande photographers and rail fans.

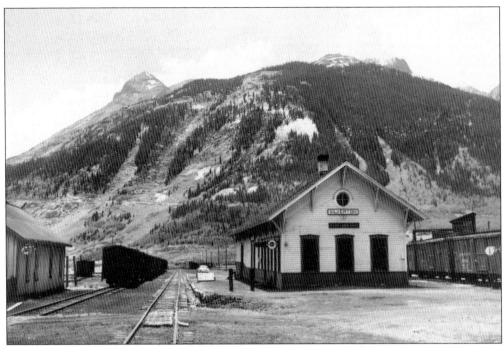

A string of D&RGW boxcars line the tracks on either side of the Silverton depot in this 1940s photograph. The image features the depot's north end and signs advertising the Railway Express Agency and Western Union Telegraph.

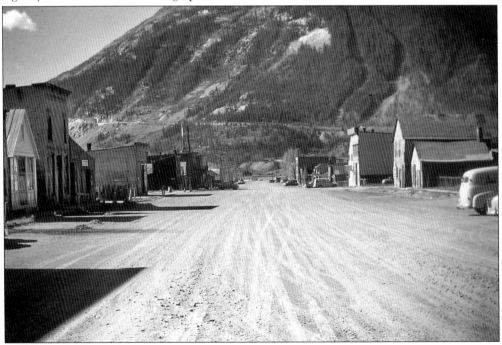

While this 1957 view gives Silverton a rather Spartan look, come tourist season the streets would be filled with passengers riding the train from Durango. Tourism would go along way in revitalizing the town after the decline of mining.

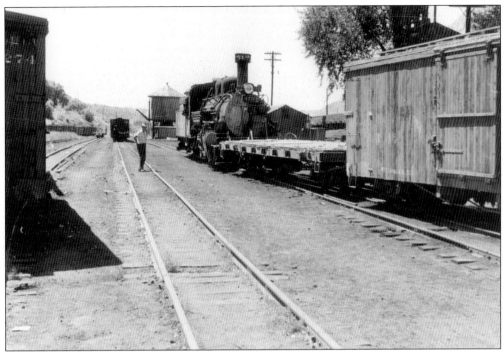

Switching freight cars was far removed from the more glamorous duties of passenger service. Despite its lowly assignment, Engine No. 473 shuttles cars in the shadow of the Durango water tank.

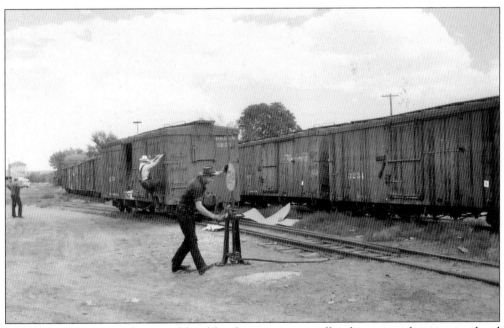

There was a science to the assembly of freight trains, especially when using the more outdated equipment facilities found on the narrow gauge. However in the hands of a capable yard crew these tasks were easily accomplished.

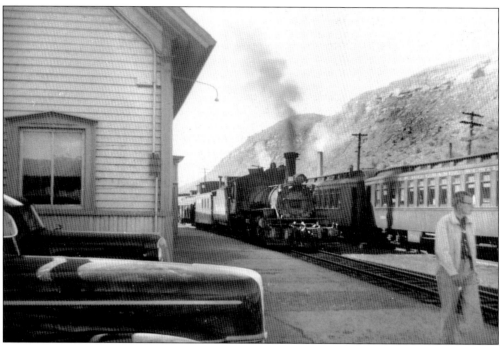

In this August 1953 photograph, switching duties are underway in front of the Durango depot. In the background is a string of passenger cars, including Coach No. 310, still in its green San Juan colors.

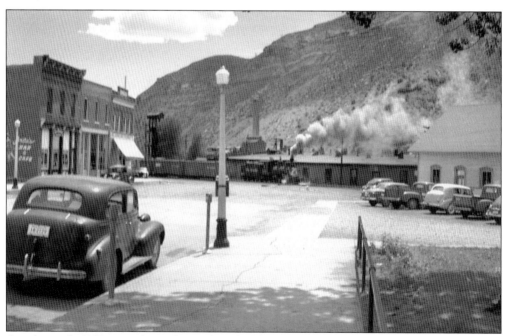

Another early 1950s view shows the south end of the Durango depot away from the tracks. Across Main Street is Anita's Bar where "Rule G," regarding the consumption of intoxicating liquors by railroad employees, was strictly ignored.

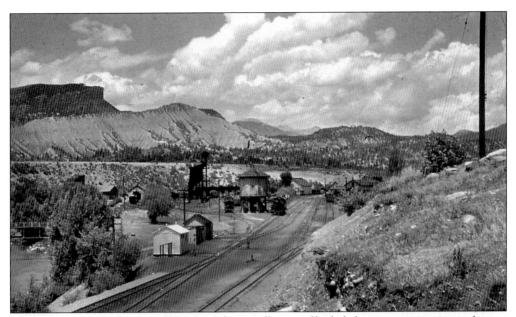

Standing on a hill below the Rio Grande roundhouse afforded this panoramic view taken in 1953. The southern end of the Durango yards contained the water tank, pump house, coaling facilities, and several outbuildings.

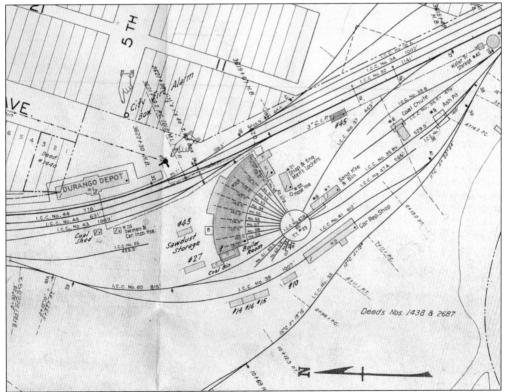

This map shows the general layout of the Durango yards, which included the depot grounds, roundhouse, and car shops, as well as the coaling and sand facilities and the water tank.

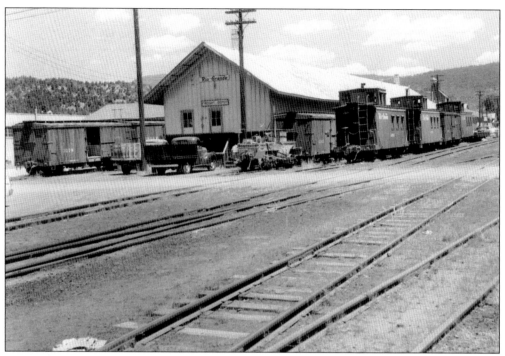

The Durango Freight Depot was located near Seventh Street, just north of the D&RGW passenger depot. When this photograph was taken, the tracks next to the depot were home to several "cabeese" and boxcars as well as a flanger.

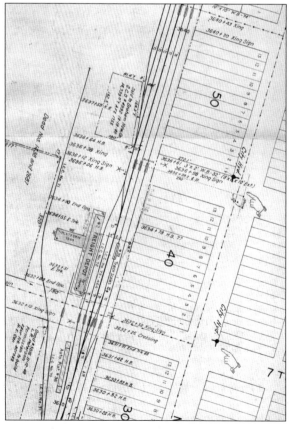

This map shows the grounds of the D&RGW's Durango Freight Depot. This location had a scale track, a loading dock to accommodate trucks, and an automobile unloading ramp.

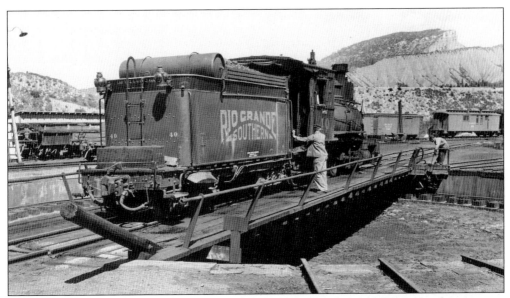

While many rail fans associate Durango with the Denver & Rio Grande Western, the town was also served by the Rio Grande Southern. This photograph shows RGS Engine No. 40 on the roundhouse turntable in the early 1940s. (Photograph by Lad Arend.)

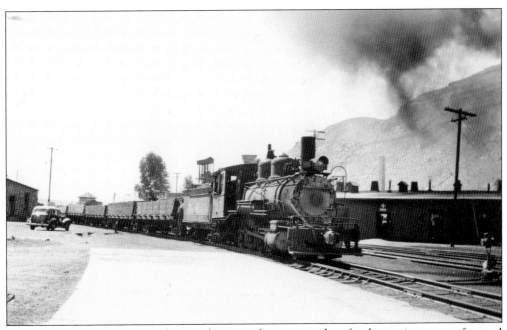

The longevity of the Rio Grande saw it become a last resting place for the motive power of several other Colorado narrow-gauge railroads. Engine No. 315, a product of the Baldwin Locomotive Company, was originally built for the Florence & Cripple Creek Railroad.

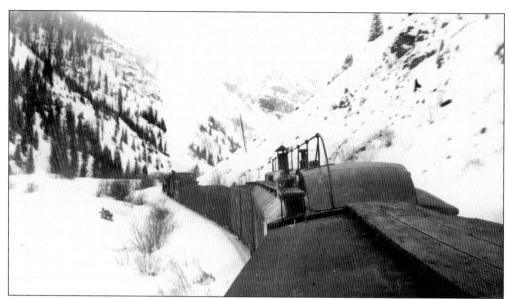

Mixed trains afforded rail fans a unique view of narrow-gauge railroading. This 1946 photograph was taken from the cupola of a D&RGW caboose while traveling along the Animas River near Elk Park. (Photograph by M. R. Henry.)

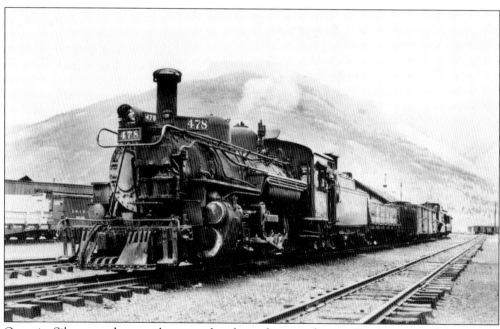

Once in Silverton, the crew began to break up the mixed train. Trailing a gondola, several boxcars, and a combine, a brakeman signals to the crew of Engine No. 478 as it backs up towards the Silverton depot.

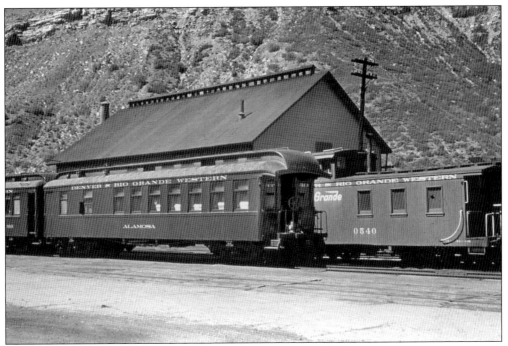

By the early 1950s, formal narrow-gauge passenger service via the *San Juan* was coming to an end. Eventually the Durango years would become a repository for passenger equipment. The "Alamosa," along with Caboose No. 0540 and Coach No. 310, is seen in this photograph.

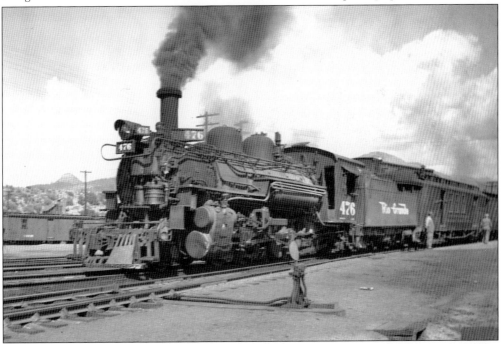

In 1952, passengers could still enjoy a train ride from Durango to Denver. The first leg of the journey was aboard the *San Juan*, pictured here preparing to leave the Durango depot and powered by Engine No. 476.

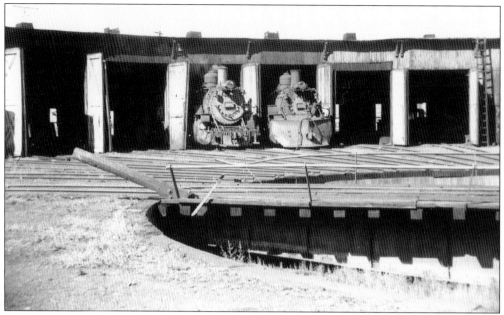

By the 1950s, the once vast Rio Grande narrow-gauge fleet of motive power had been greatly reduced. The dwindling engine pool and increased freight volumes brought larger Class K-37 engines like Nos. 498 and 491 to Durango.

The 1950s were a period of great change for the Rio Grande and served to expand the separation between the contemporary standard gauge and the aging narrow gauge. Although veterans in steam operation, many of the Durango crews had little experience with the modern engines used on other parts of the line. No doubt these conditions prompted many local railroaders to take a break and wait for what came next.

Four

A Trip along
the Animas

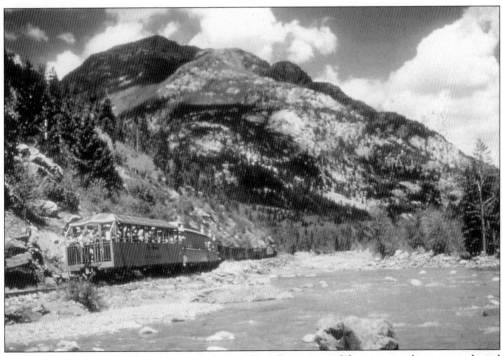

One of the most spectacular ways to see the trip from Durango to Silverton was from a seat aboard the glass-topped *Silver Vista*. Introduced in 1947 in response to growing ticket sales, this car made many trips through the Animas Canyon before it was destroyed in a fire in 1953.

For some rail fans, preparations to ride the Silverton began the night before with a stay at the Strater Hotel. The Strater was one of the most historic and finely appointed hotels in town and was a favorite with many Durango visitors.

STRATER HOTEL
DURANGO, COLORADO

While sleeping tourists dreamed of coal smoke and screaming flanges, the night crews at the Durango shops were busy preparing the engines and coaches for the next day's run. A crewless Engine No. 478 posed for this 1961 photograph in front of the darkened silhouette of the coaling tower.

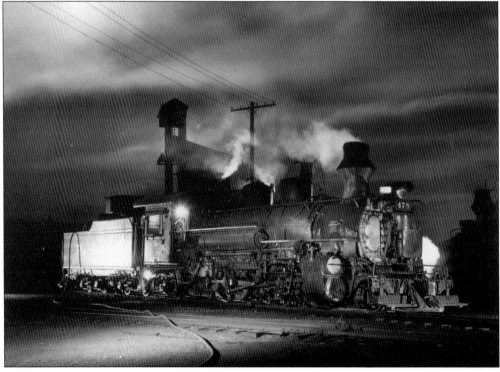

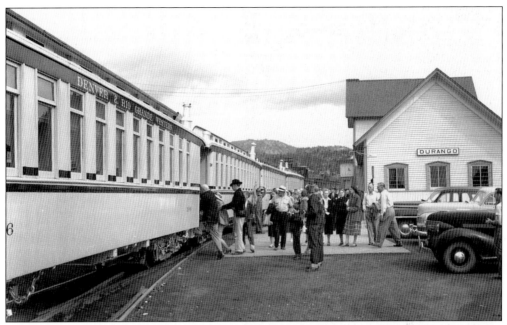

Early the next morning, the rush is on. *The Silverton* is ready for its journey north and anxious passengers, armed with jackets and cameras, wait their turn to get on board.

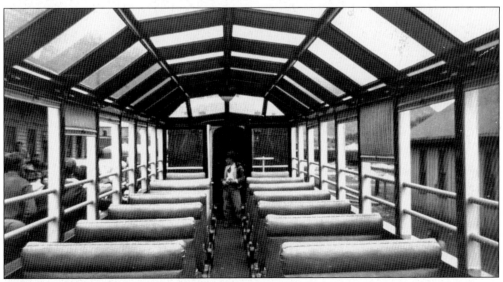

This photograph shows the interior of the *Silver Vista*. While the seats are empty for the moment, the crowd standing outside the Durango depot, left, will soon fill them up.

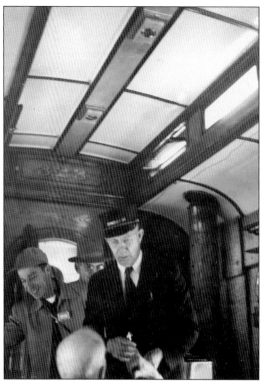

Tickets please! The crew aboard *The Silverton* not only looked after the operation of the train but also took time out to answer questions. In this view, venerable conductor Alva "Al" Lyons pauses to talk to a passenger while passing through Coach No. 323.

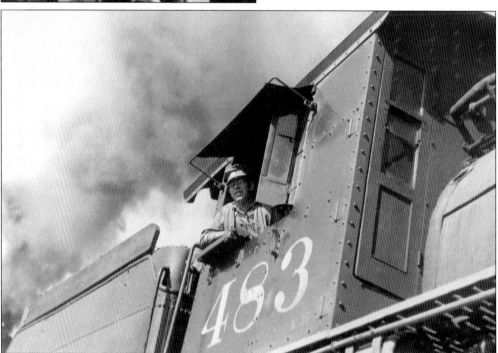

Perhaps the most popular attractions around the Durango yards were the narrow-gauge locomotives and their crews. In this photograph, the engineer of No. 483 engages in conversation while waiting for the clearance that will send him north.

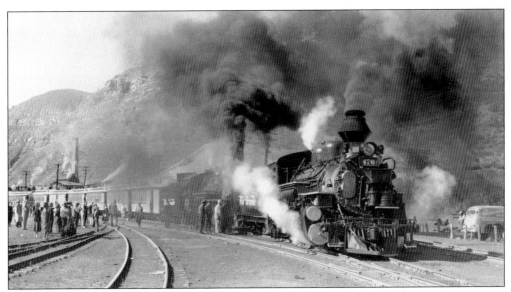

For those who had a ticket and those watching with ready cameras, train time at Durango was exciting. In this 1956 photograph, rail fans line the tracks waiting for Engine No. 478 to depart for Silverton.

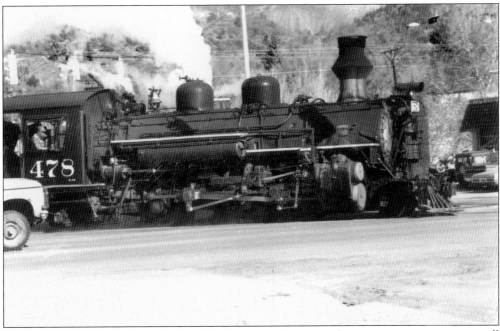

By the 1960s, Durango was one of the few towns in America where narrow-gauge engines still stopped traffic and turned heads. Here Engine No. 478 navigates a downtown-grade crossing before its passage across the Animas River.

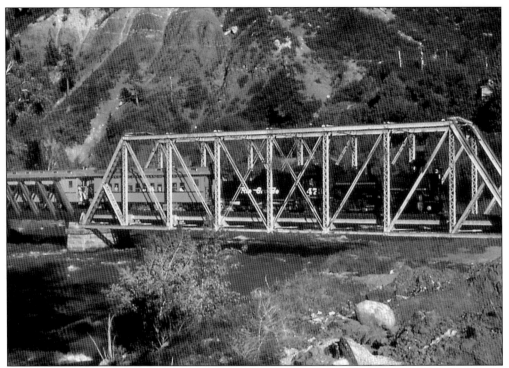

Over the years, the Rio Grande had built several bridges over the Animas River. One of the most scenic, however, was this steel bridge where Engine No. 473 and its northbound train head through Durango.

Leaving Durango and Animas City, Rio Grande passengers were able to take in the beauty of the Animas Valley. The red ridges and fertile farmlands found here were a strong contrast to the tight confines of the waiting Animas Canyon.

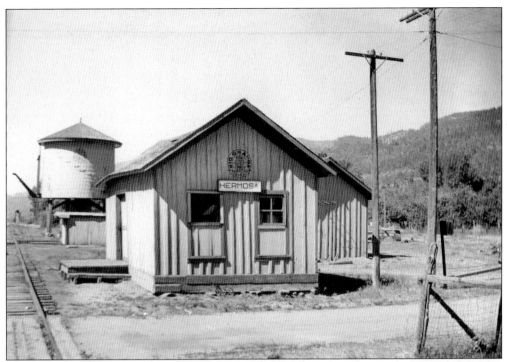

For trains bound for Silverton, Hermosa was the first water stop out of Durango. Meaning "beautiful" in Spanish, the community and nearby cliffs are aptly named.

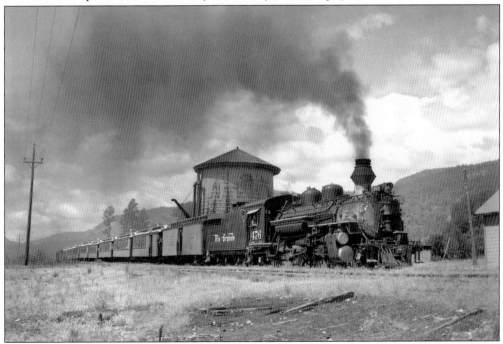

Engine No. 476 pauses at Hermosa for this photograph, taken in 1947. Once this modest depot was reached, the northbound trains would begin to gain the elevation needed to continue their journey to Rockwood and beyond.

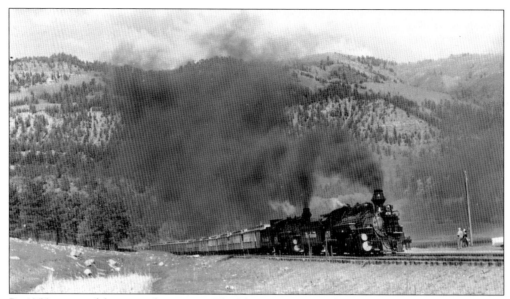

By 1955, more rail fans were discovering *The Silverton*. Meeting this increase demand, the railroad added additional coaches, which sometimes required the tractive effort of two locomotives. Pacing the doubleheader, Ernie Peyton captured this scene along a dirt road between Hermosa and Rockwood. (Photograph by Ernie Peyton.)

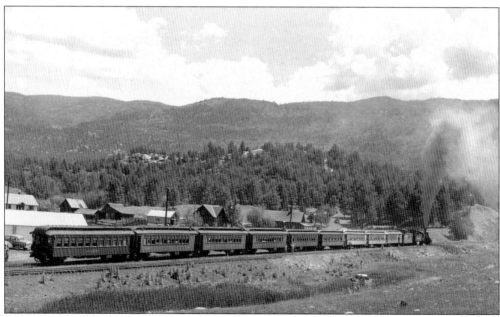

This panoramic photograph taken at Rockwood illustrates the number and types of passenger cars that comprised *The Silverton*. It is interesting to note that when this photograph was taken in 1953, some of the coaches still appeared in their old San Juan colors.

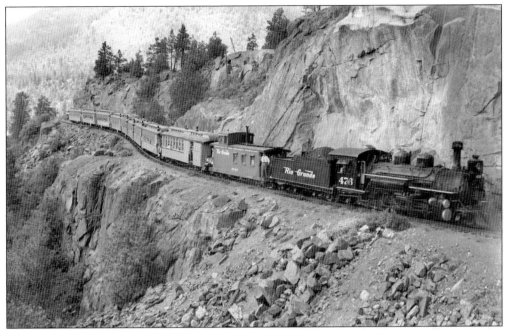

Perhaps the most scenic point between Durango and Silverton is the cliff-hanging stretch of track above the Animas River, known as the High Line. Posing for the camera here in 1955 is Engine No. 476 with Caboose No. 0540 and a long line of coaches.

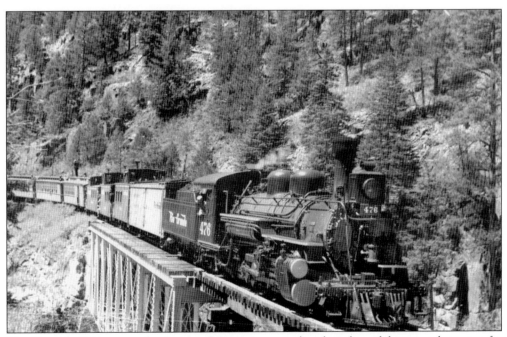

The Cascade Bridge over the Animas River was a popular place for rail-fan specials to stop for photograph "run bys." In this image, Engine No. 476 pulls an interesting consist, including coaches, several "cabeese," and a refrigeration car.

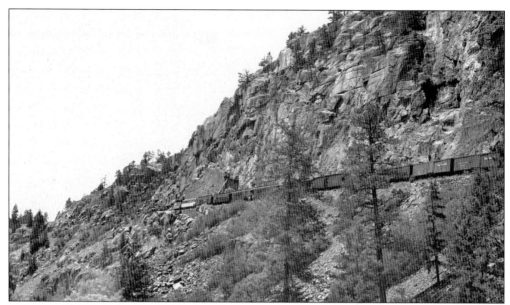

Before the establishment of *The Silverton*, rail fans could travel over the High Line aboard mixed trains like this one. The open car *Silver Vista* appears towards the end of the train.

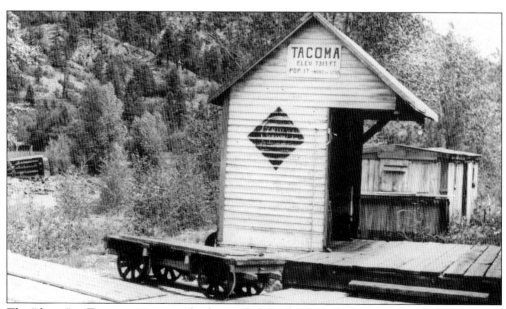

The "depot" at Tacoma was more of a three-sided shack where the rural stature was exemplified by a sign reading, "Pop. 17 more-or-less." The depot's interesting Rio Grande logo resulted from an appearance in Paramount's 1951 filming of the movie *Denver and Rio Grande*.

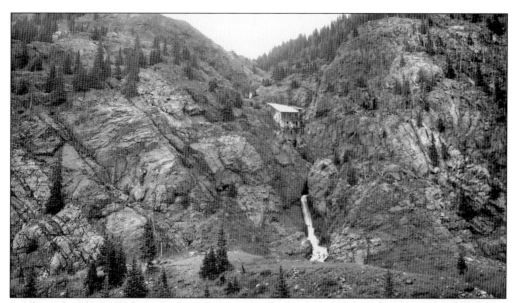
As the railroad traveled north along the Animas River, passengers were treated to many scenes of natural beauty. The tracks also passed several old mines that served as a precursor to the heritage of Silverton.

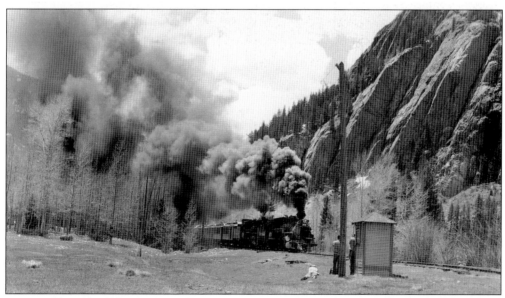
Among the railroad "facilities" at Elk Park was this telephone booth. In this photograph, several rail fans can be seen photographing the approach of a doubleheader powered by Engines No. 476 and No. 478.

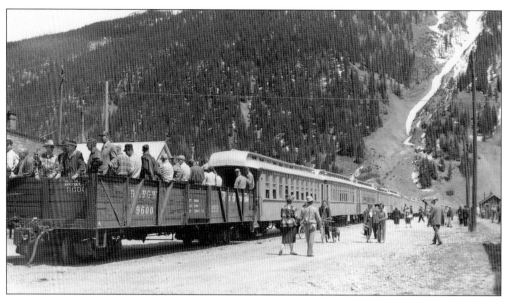

Having taken in all that Silverton had to offer, passengers returned to the train that will take them back to Durango. Serving as the shutterbug's "standup" car on this run is outside-braced gondola No. 9600.

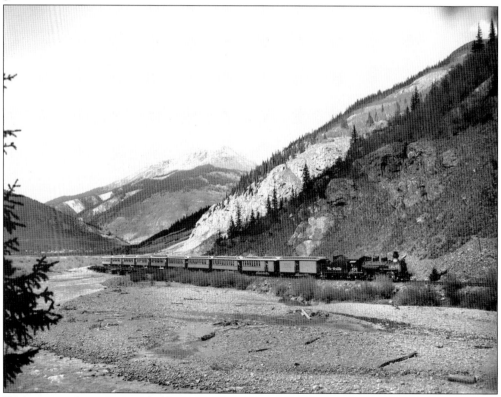

With its round-trip journey halfway complete, Engine No. 476 is pictured leaving Silverton on its way back to Durango. The platforms of many of the coaches are filled on this trip, and even the baggage car has a couple of passengers.

Five

CONNIES, MIKES, AND MOVIE STARS

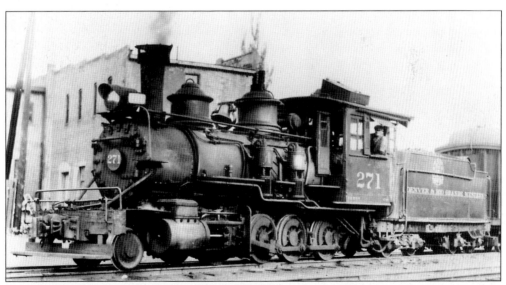

Consolidation No. 271 was built by the Baldwin Locomotive Works in 1882 and is pictured in Durango in 1937. Like other Class C-16 veterans, this locomotive saw service on other lines, including the Rio Grande Western Railway. In 1941, it was sold to the Montezuma Lumber Company.

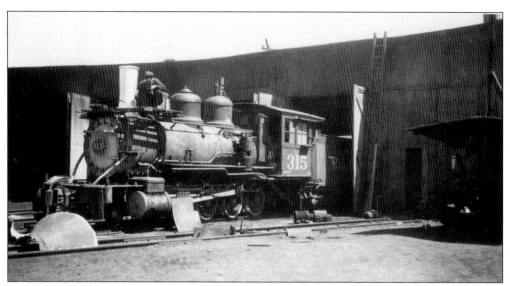

Engine No. 315 was originally built for the Florence and Cripple Creek Railroad as their No. 3, the "Elkton." It later saw service on the D&RG, first as No. 425 and later as D&RGW No. 315. This photograph shows one of the Durango roundhouse crew doing some "cosmetic surgery."

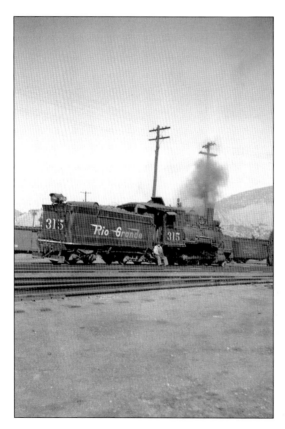

No. 315, a 2-8-0, is pictured again in 1946 switching cars near the Durango depot. This Class C-18 engine was retired in 1950 and donated to the City of Durango, where it is currently being restored to operating condition.

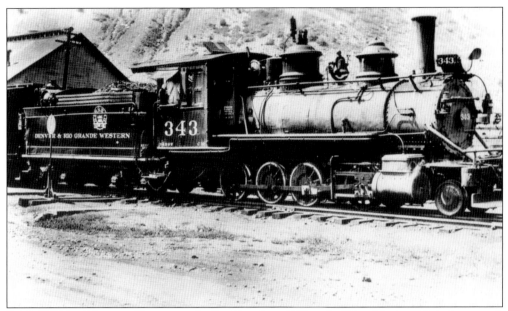

D&RGW No. 343 originally came to the Rio Grande in 1881 as the "New Mexico." This photograph was taken in Durango in 1933, eight years before the engine was retired.

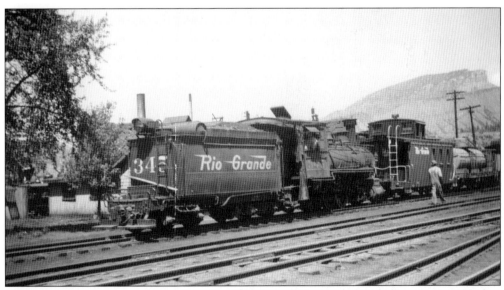

Originally christened the "Grand River" in 1881, it would later wear No. 803 and No. 405 before becoming No. 345. Posing for the camera in Durango, this Class C-19 engine was scrapped soon after its climactic "cornfield meet" in the movie Denver and Rio Grande.

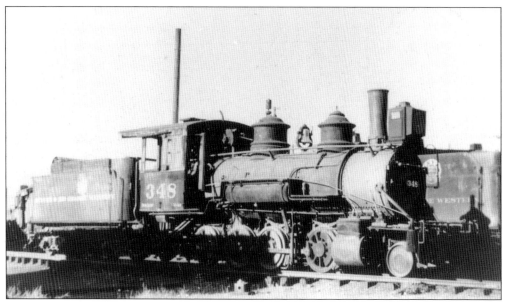

Despite the rigors of mountain railroading, the Rio Grande was able to extend the service life of many of its older locomotives. Built in 1881, this photograph shows No. 348 still working around Durango in the 1930s.

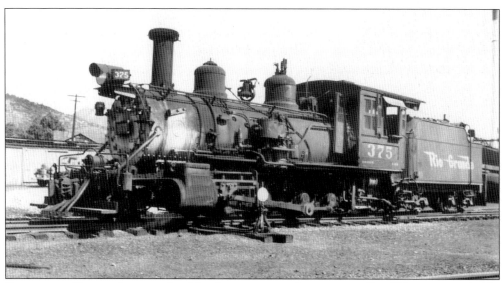

Even among Durango's assorted stable of narrow-gauge locomotives, No. 375 was an anomaly. Sometimes referred to as "Connies," this Class C-25 Consolidation was originally Crystal River Railroad No. 103 and is pictured in Durango in 1944.

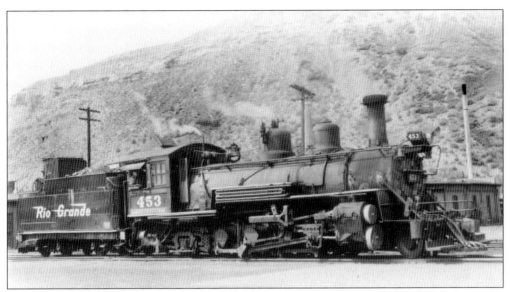

Called "Mikes" by rail fans, Mikado Class K-27 2-8-2 locomotives were a quantum leap in tractive effort compared to the smaller 2-8-0 Consolidations. Engine No. 453 is pictured here near the Durango roundhouse in 1949.

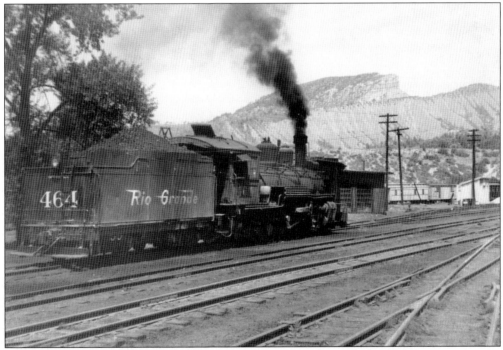

Baldwin Locomotive Works built No. 464 in 1903 as part of an order for 15 engines. Originally delivered as a vauclain compound, it would later be equipped with piston valves. This image was taken in July 1957.

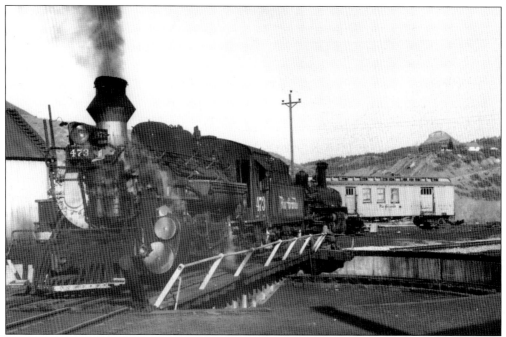

The Rio Grande's narrow-gauge operations required many of its locomotives. Engine No. 473 would be used in both freight and passenger service and is pictured here on the Durango turntable.

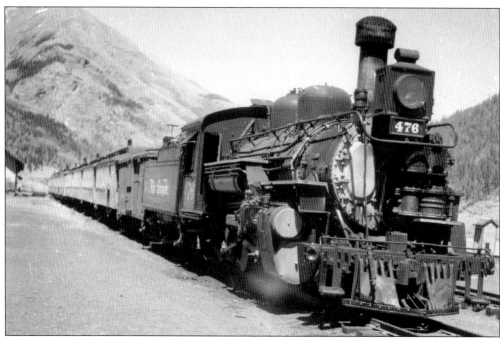

During the early 1940s, the war effort's need for narrow-gauge locomotives in Alaska greatly thinned the Rio Grande's roster of Class K-28 engines. One of the survivors, No. 476, is pictured here in Silverton in 1955.

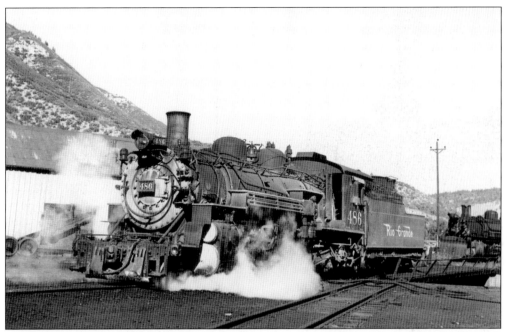

Heading towards the south part of the Durango yards in this 1960 photograph is Engine No. 486. One of the D&RGW's Class K-36 locomotives, the engine was retired in 1962. It was recently rescued from display at the Royal Gorge to once again ride the rails of Durango. (Photograph by Alfred Jaeger.)

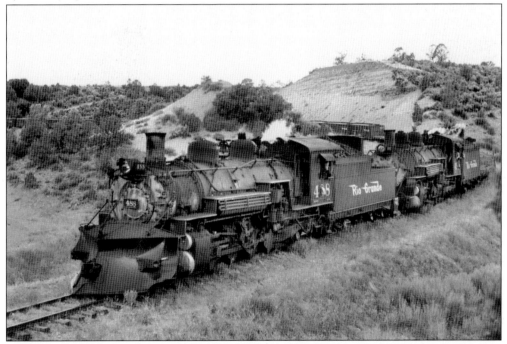

The added tonnage of freight moving between Chama and Durango sometimes saw two locomotives on the freight runs. In this photograph, Engines No. 488 and No. 497 pull freight near Florida, Colorado, in 1961.

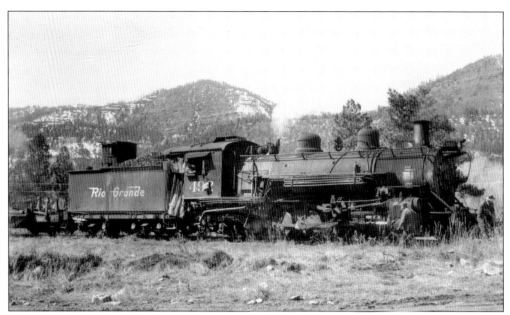

The heavier Class K-37 locomotives routinely visited Durango on Farmington-bound freight runs but due to bridge and clearance limitations, could not run above Rockwood. This rare photograph shows Engine No. 492 with a maintenance train near the Hermosa tank.

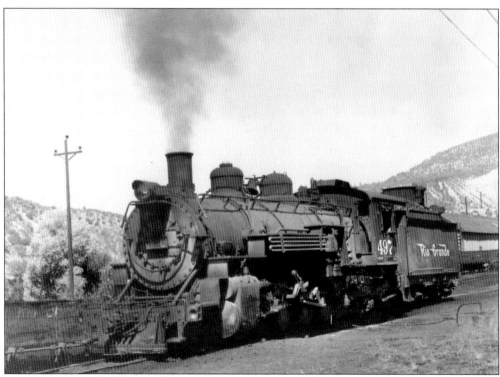

Periodically freight conductor Roland Parsons would take a break from his duties on the Moffat Line and venture into narrow-gauge country. Parsons captured this photograph of Engine No. 497 in the Durango yards in August 1963. (Photograph by Roland Parsons.)

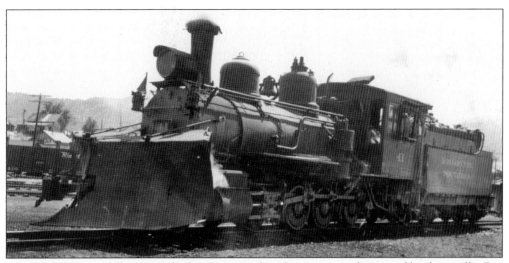

The D&RGW was fully entrenched in Durango, but the town was also served by the smaller Rio Grande Southern. This August 1947 view shows RGS Engine No. 41, the former D&RG No. 409, working in Durango. (Photograph by W. O. Gibson.)

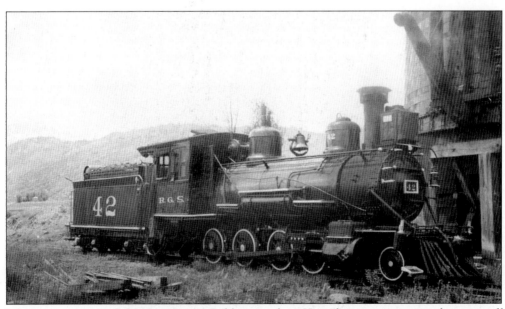

Like its sister No. 41, RGS No. 42 was a Baldwin product. Here the engine is pictured topping off at Ridgway, Colorado, the other end of the Rio Grande Southern. (Photograph by Joe Schick.)

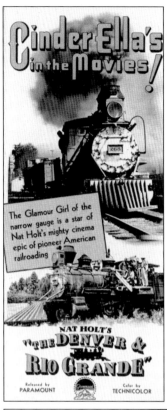

The Glamour Girl of the narrow gauge is a star of Nat Holt's mighty cinema epic of pioneer American railroading

NAT HOLT'S "THE DENVER & RIO GRANDE"

Released by PARAMOUNT Color by TECHNICOLOR

In the summer of 1951, Paramount Pictures arrived in the Animas Canyon to begin filming its epic *Denver and Rio Grande*. In cooperation with director Nat Holt and his staff, D&RGW's Passenger Department put out this brochure touting its narrow-gauge "queen," Engine No. 268, and the railroad's collaboration with Hollywood.

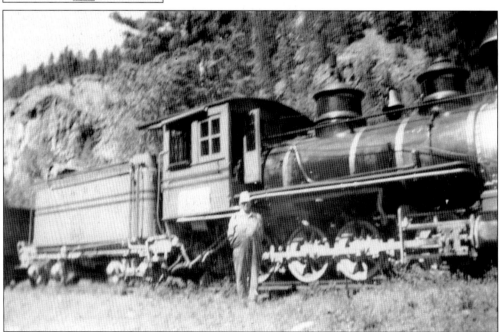

The production company engaged the help of many locals, including some of the railroad crews. A regular on the Durango–Silverton run, engineer John "Jack" Dieckman was invited to Scrap Iron Junction to lend his technical expertise.

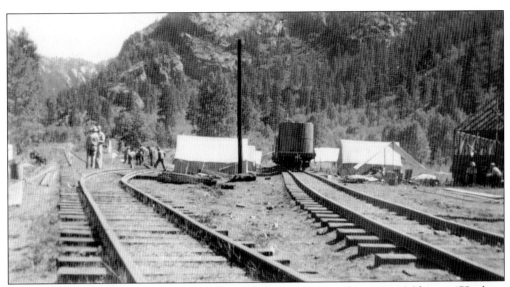

One of the sets for the movie is pictured here along the Animas River near Milepost 475 where a collection of tents and equipment was established. These tents not only served as part of the movie set but also as living quarters for some of the extras during filming.

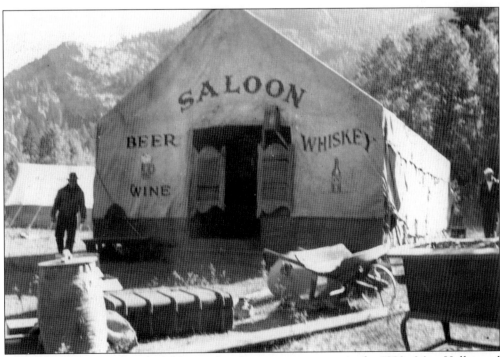

The movie set was made to look like a railroad construction camp in the 1880s. Most Hollywood Western sets were not complete without a saloon, and although this movie's watering hole had a canvas roof, it still had a pair of swinging doors.

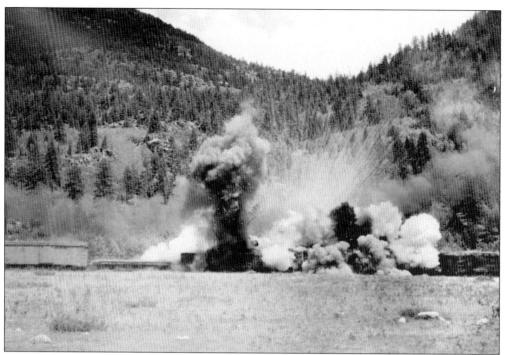

While the movie *Denver and Rio Grande* was destined to become a classic western movie, it also contained this scene—one of the most celebrated staged railroad wrecks in movie history. Hidden behind the cloud of smoke, steam, and flying debris are the remnants of Engines No. 319 and No. 345.

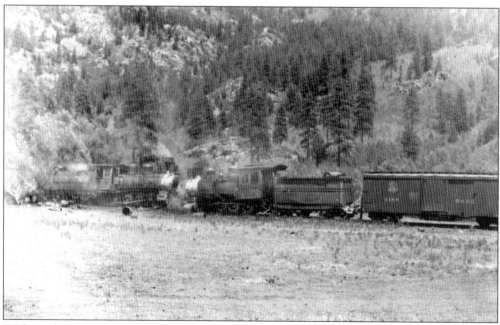

With smoke still pouring out of No. 319's wounded boiler, this post-wreck photograph shows the engine hulks still upright on the tracks. Between the two locomotives is a mess of twisted iron and pilot trucks.

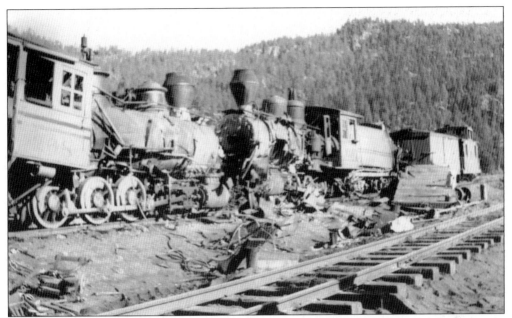

This photograph shows the aftermath of the wreck from the other side of the tracks. Representing the Rio Grande in public appearances, Engine No. 268 had become very popular with the public and while featured in the movie, was replaced in the wreck sequence by No. 345 painted to look like No. 268.

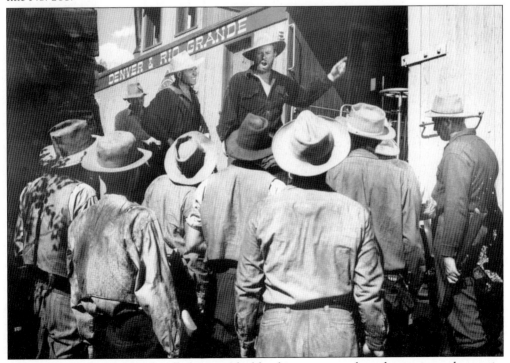

After filming was completed, still photographs like this one were released to promote the movie. This still image shows actor Sterling Hayden inciting a railroad crew to action as gun-for-hire Lyle Bettger looks on.

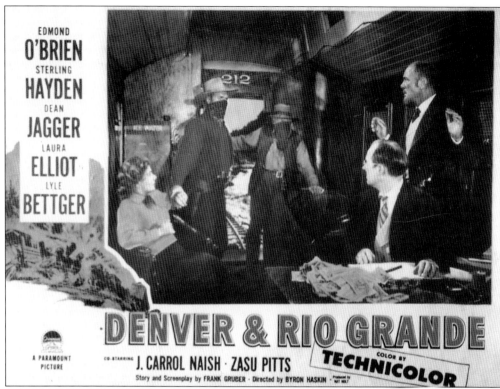

Lobby cards, like the one seen here, were distributed to movie theaters when *Denver and Rio Grande* was released in 1952. Promotional items like this have since become prized collectables.

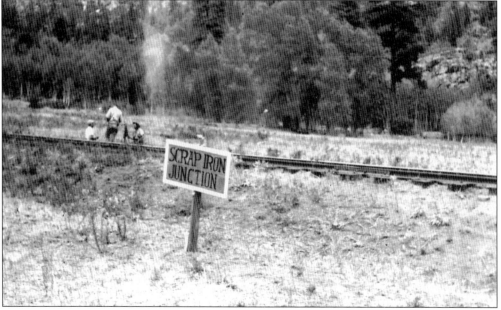

The spot along the Animas River that was selected for the crash site became known as Scrap Iron Junction. This photograph shows the sign that has already been erected, marking the point of impact.

Six

COAL, CATTLE, COACHES, AND "CABEESE"

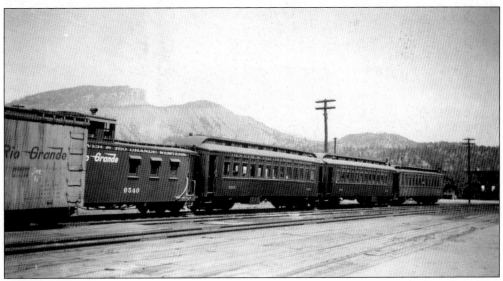

The discontinuation of the *San Juan* had a silver lining as the surplus of passenger equipment found a home on the growing *Silverton*. Taken near the Durango depot, this photograph shows Caboose No. 0540, Coaches No. 325, No. 323, No. 284, and an unidentified refrigeration car.

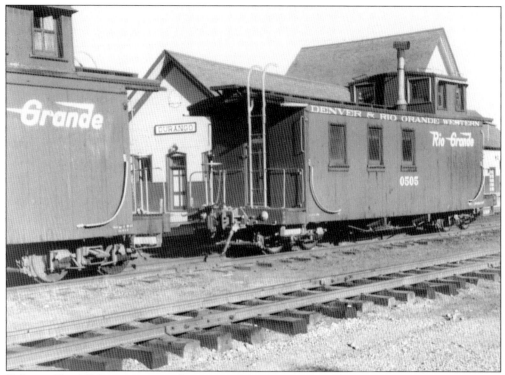

Caboose No. 0505 was a seasoned veteran of the Durango to Silverton run and saw service on many freight and mixed runs. This view was taken in front of the Durango depot.

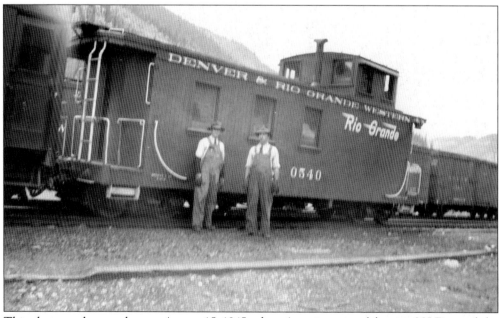

This photograph was taken on August 15, 1945, when America was celebrating V-J Day and the end of World War II. However in Silverton, Colorado, it was business as usual for Caboose No. 0540 and the crew of a Rio Grande freight train.

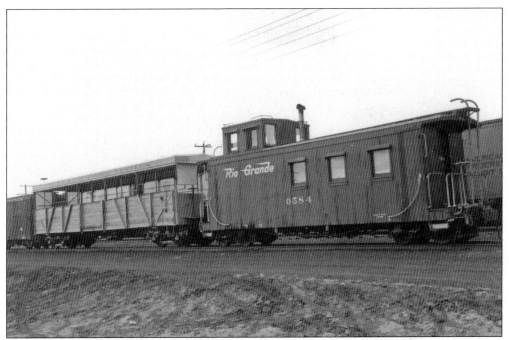

By the early 1960s, the need for additional passenger equipment on *The Silverton* saw the addition of Rio Grande–built open gondolas. These cars, sometimes used at other points along the narrow gauge as Caboose No. 0584 and open Car No. 400, are pictured here in Alamosa.

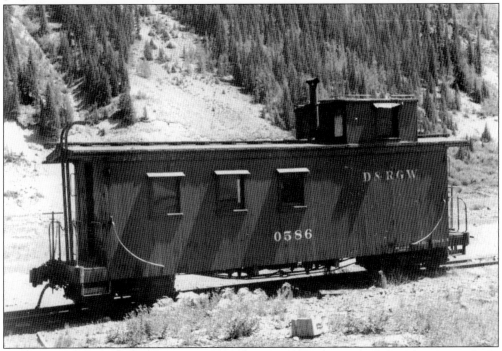

It was not unusual to see older pieces of Rio Grande equipment around the Silverton yards. In this photograph, a rail fan caught an aging Caboose No. 0586 with a faded letter board that still read, "Denver & Rio Grande Western."

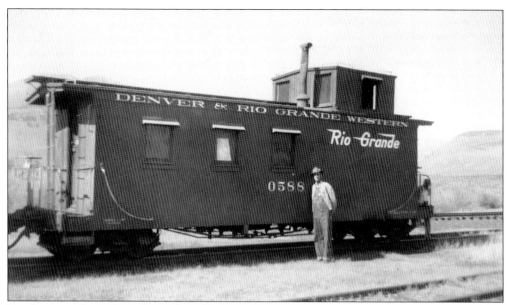

For the men who rode in them, the caboose was an office and sometimes their sleeping quarters as well. In this photograph, one of the Rio Grande's narrow-gauge freight conductors pauses in front of Caboose No. 0588.

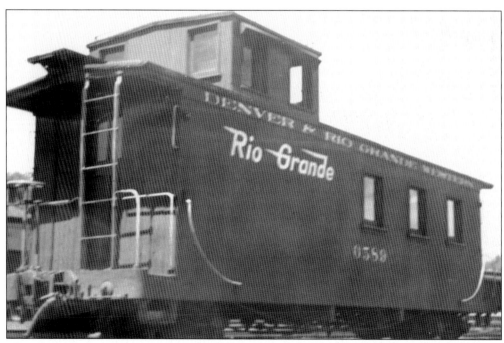

This photograph shows the cupola and end detail of Caboose No. 0589. These vantage points were ideal for photographers looking for unique camera angles.

The Rio Grande carried its propensity for miniaturized narrow-gauge equipment to its fleet of "cabeese." Known sometimes as "bobbers," the Rio Grande also employed "shorties," like No. 0575.

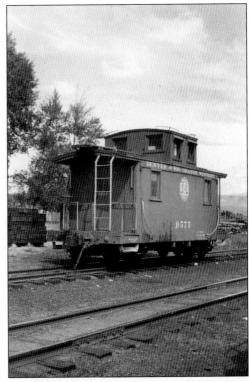

Nos. 0505 and 0540 were common sights on both freight and mixed runs to Silverton. Despite their frequent use, the pair has found narrow-gauge immortality, and both have survived into the modern era.

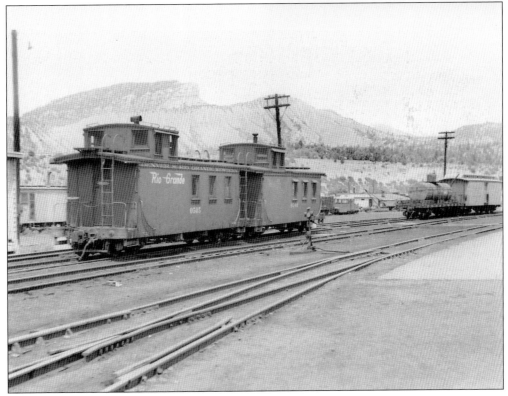

Wood gondolas No. 1741 and No. 1656 are pictured just north of the Durango depot in 1961. The increased freight activity on the Farmington Branch in the 1950s helped to extend the lives of cars like these.

By 1958, when this photograph was taken, the steadily shrinking narrow gauge was starting to build up a surplus of freight cars. One of the 800 Series gondolas, No. 806, is seen here just a few blocks north of the Durango depot.

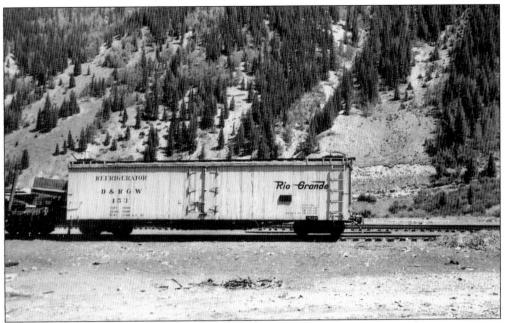

Refrigerator cars like No. 153 were also used on the Silverton line. In later years, some refrigeration cars had their trucks removed by the railroad in Alamosa and the bodies purchased by San Luis Valley farmers for storage.

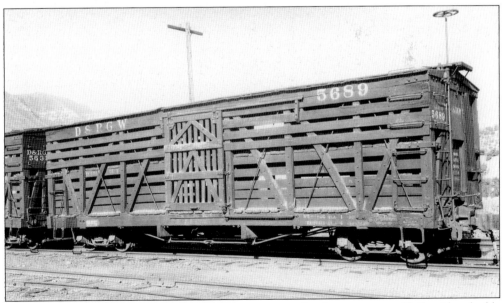

Stock cars once played a prominent role in narrow-gauge freight movements. Built with a double deck, D&RGW Car No. 5689 could accommodate two "layers" of sheep.

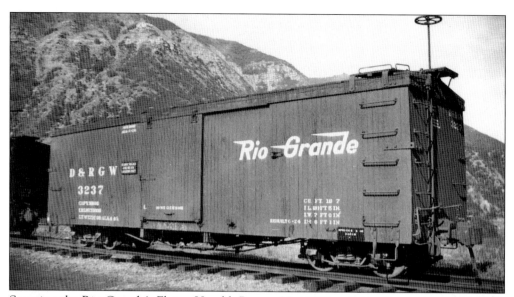

Sporting the Rio Grande's Flying Herald, Boxcar No. 3237 waits in Durango around 1948. Although the need for narrow-gauge freight equipment had started to decline, over 300 of these cars were still in service a decade later.

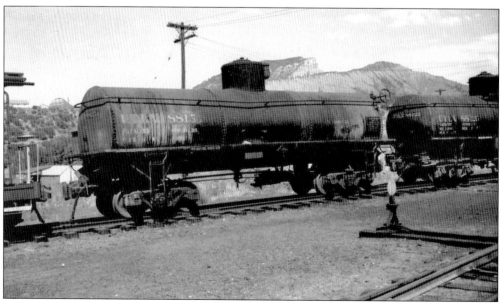

Bulk petroleum products were moved through Durango, especially during the oil and gas boom around Farmington. This photograph was taken of UTLX Tank Car No. 88154.

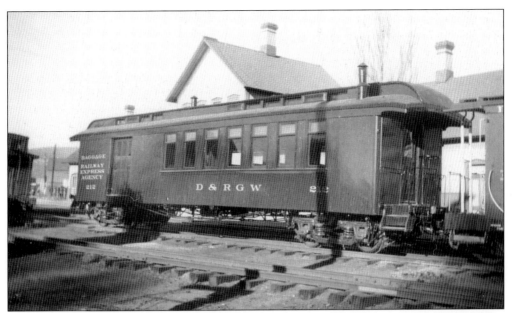

During the 1940s, the many rail fans who took the "mixed" train to Silverton did so in Combine No. 212. This image was taken in 1946 in front of the Durango depot.

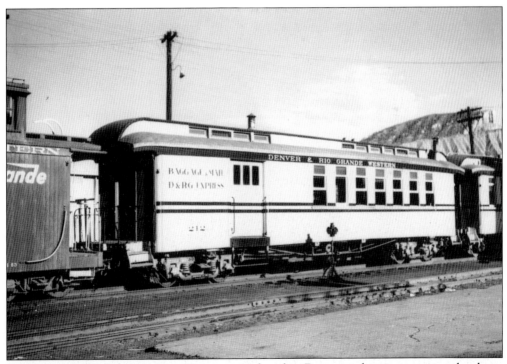

On June 19, 1953, Combine No. 212 was again found in Durango, this time wearing the short-lived, two-stripe paint scheme. This car was built by Barney and Smith in 1878, about the same time the railroad "war" alluded to in the movie *Denver and Rio Grande* actually took place.

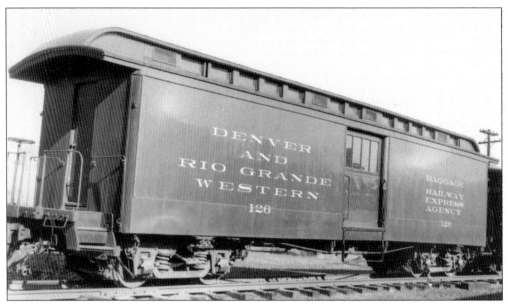

Pictured in the green colors of San Juan, Baggage Car No. 126 was to become the last of its kind and sometimes saw service as the "overflow car" on the more heavily patronized runs out of Durango. The car also had a role in the 1953, 20th Century Fox movie *Three Young Texans*.

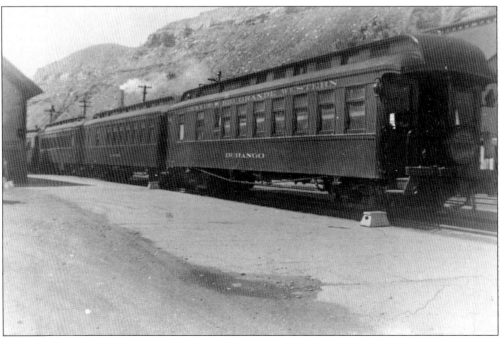

Wearing the round San Juan drumhead, the parlor-buffet car "Durango" waits in front of its namesake depot in 1949. This car was originally built by Jackson and Sharp in 1880 and rebuilt by the Rio Grande in 1937.

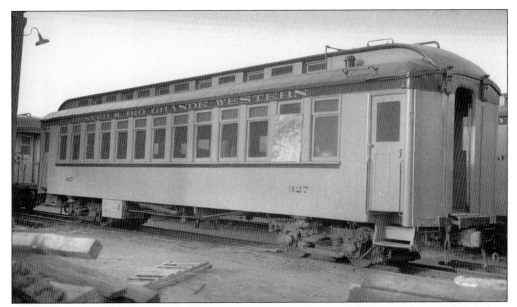

This photograph of the No. 327 is a fine example of one of Rio Grande's closed vestibule coaches. This car was originally built by the D&RG in 1887 and rebuilt again when some of the narrow-gauge passenger fleet was overhauled in 1937.

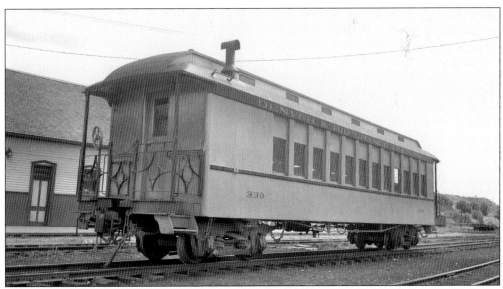

Also popular and more numerous were the open vestibule coaches. Waiting to be filled with anxious passengers, Coach No. 330 sits at the Durango depot.

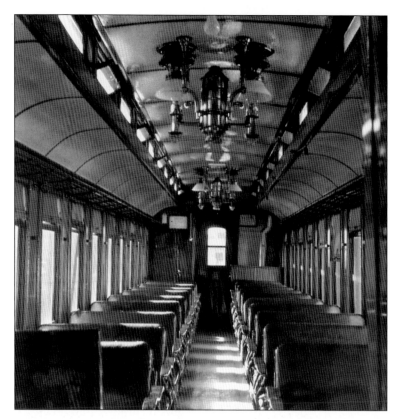

In the late 1940s, some Rio Grande narrow-gauge coaches like this one still had their ornate interior lighting. As the passenger fleet was thinned, some of these brass fixtures were given away as retirement gifts or to visiting dignitaries. (Photograph by Bert Ward.)

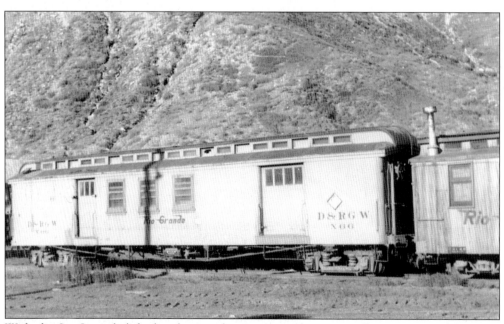

With the *San Juan* abolished and no mail contracts, railway post-office cars around Durango became obsolete. Non-revenue Car X-66 met such a fate, was repainted in MOW grey, and consigned to maintenance service.

Seven

PORTRAITS OF POWER

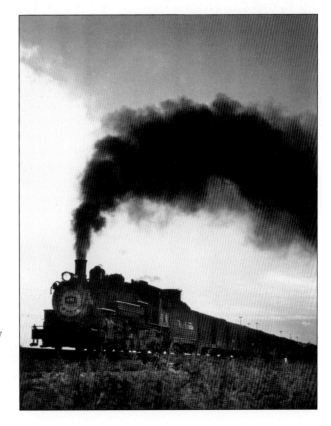

This scene of Engine No. 491 steaming off into the sunset was indicative of the thoughts of many rail fans in the early 1950s. The Rio Grande was actively getting out of the narrow-gauge business, and the fate of the Silverton Branch was in the balance.

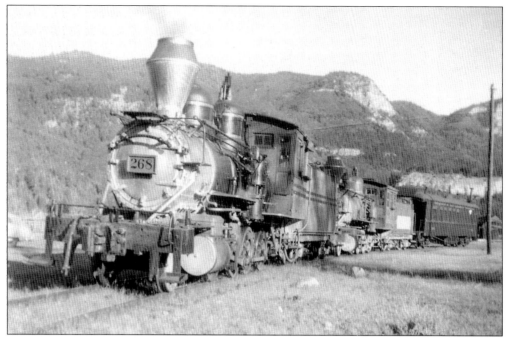

Few locomotives ever boasted a movie double, but during the crash scene in the movie *Denver and Rio Grande*, Engine No. 345 stood in for the more famous No. 268. In this 1951 photograph, No. 268 pauses at Rockwood, followed by No. 319, en route to its appointment with destiny. (Photograph by Roland Parsons.)

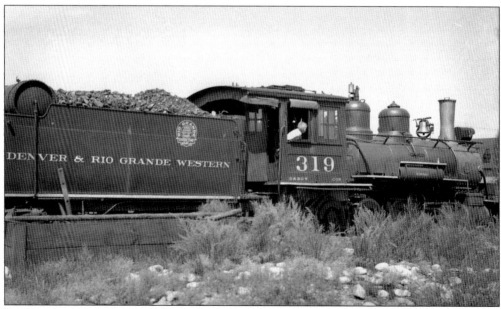

Twelve years before its movie debut in 1951, Engine No. 319 played host to a young rail fan and his imagination. This engine was originally built for the Florence and Cripple Creek Railroad where it served as Engine No. 9, the "Alta Vista."

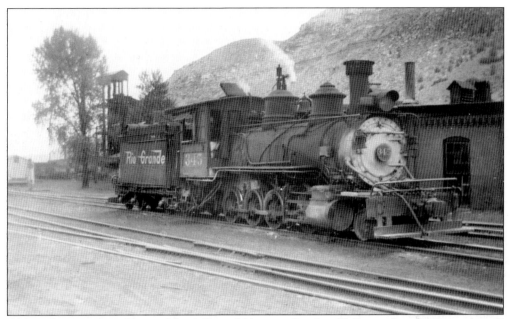

Although a year later Engine No. 345 would be sacrificed to Hollywood, in 1950, it was still serving as the Durango yard goat. Its vintage tender and ornate domes gave the 2-8-0 a nostalgic appearance and made it a favorite with visiting photographers.

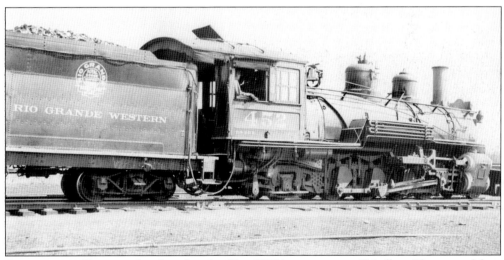

Engine crews affectionately referred to the Class K-27 locomotives as "Mudhens" because of their gait and propensity to scoot off the rails. This photograph of Engine No. 452 was taken during prewar operations.

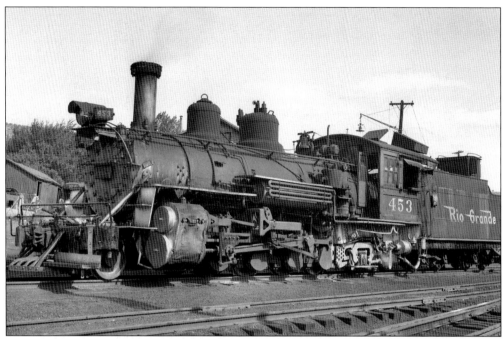

Engine No. 453 was another "Mudhen" and a regular around the Durango yards. Taken in 1950, this photograph shows the 2-8-2 all coaled up and ready to start working. (Photograph by Clyde Jenkins.)

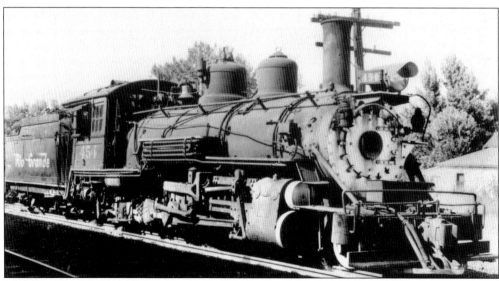

Like the other 15 Class K-27 locomotives, Engine No. 454 was built in 1903 by Baldwin. Taken near the end of its career, this photograph shows No. 454 in Durango in 1952.

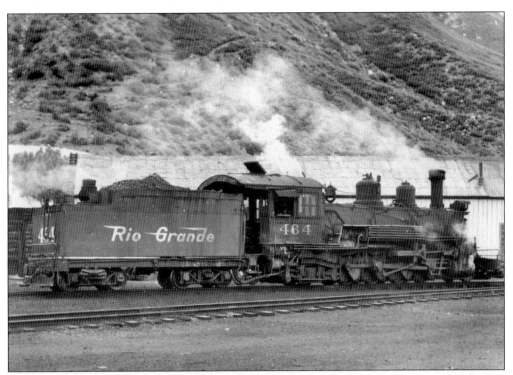

The last number in its class, Engine No. 464 would also be the last Mudhen to serve the Rio Grande. This photograph was taken in Durango in August 1957; five years later, the engine was retired and later sold to Knott's Berry Farm.

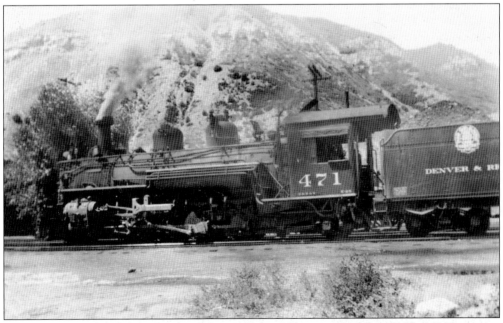

During the early 1940s, the needs of America's war effort saw 7 of the 10 Class K-28 engines drafted for use on the White Pass and Yukon. Engine No. 471, pictured in Durango before the war, was one of the locomotives destined for Alaska.

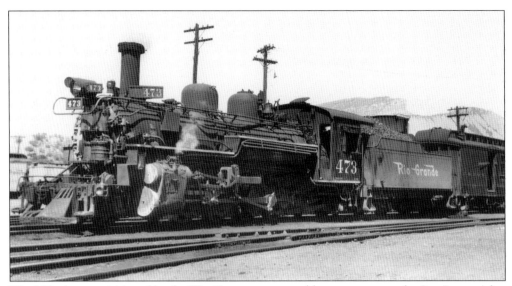

The Mikados, requisitioned by the War Department, would never return to the San Juans. After the war, the Rio Grande was left with only three K-28s. Engine No. 473, one of the survivors, is pictured at the head of the Alamosa-bound *San Juan* in 1948. (Photograph by Frank O. Kelly.)

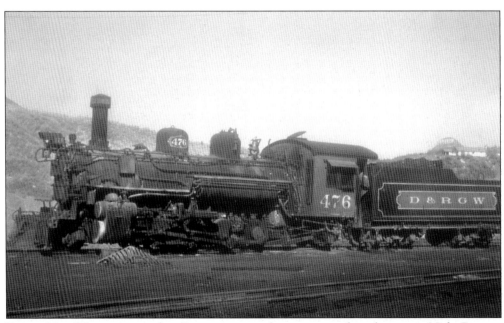

Engine No. 476 was captured in Durango soon after it appeared in the movie *Night Passage*. During the movie, the electric headlight was removed and replaced with a large oil-burning dummy headlight.

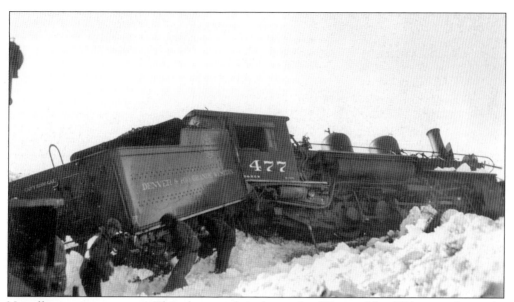

Not all portraits are pretty. This photograph is the result of Engine No. 477 leaving the tracks while on its run between Alamosa and Durango at the head of Train No. 115.

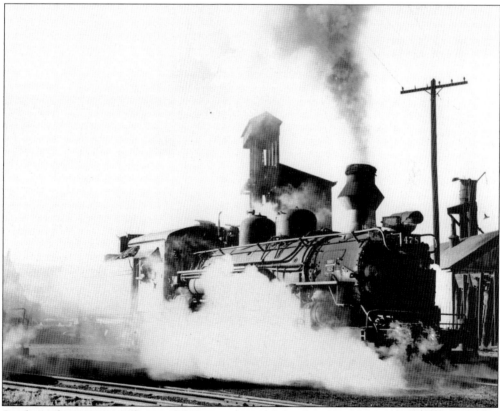

Smoke and steam were all part of the narrow-gauge experience and both emanate freely in this photograph of Engine No. 478. The Durango coal dock can be seen the background of this 1961 image. (Photograph by Alfred Jaeger.)

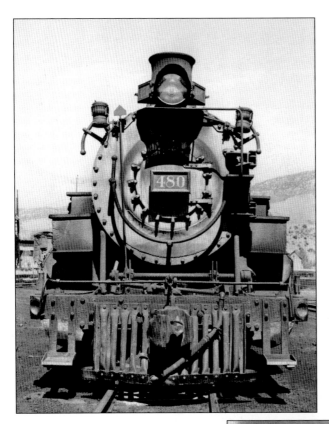

The Rio Grande's three-foot-gauge engines were a unique form of railroading, as were their nautical maker lights.
This head-on view of Engine No. 480 was taken in the Durango yards in 1961. (Photograph by Alfred Jaeger.)

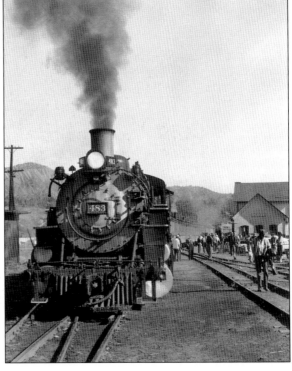

Waiting alongside its disembarking passengers, Engine No. 483 has just completed another run with *The Silverton*. Like several locomotives in its class, this engine would carry many more passengers for numerous years. (Photograph by George Schlaepfer.)

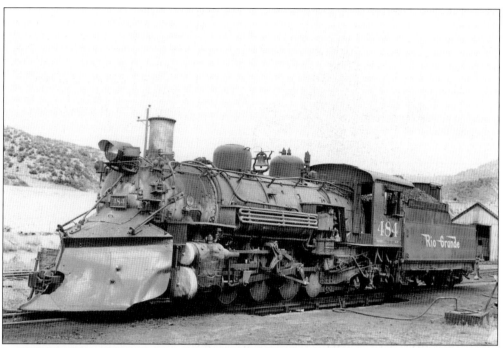

It was July 1961, and Engine No. 484 still had its snowplow when this photograph was taken. However winter and the waiting drifts of Cumbres Pass were never far away. (Photograph by Alfred Jaeger.)

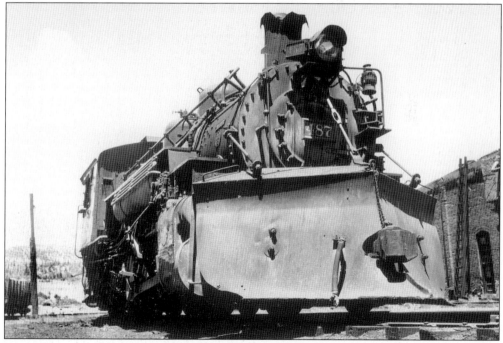

In another part of the yard on that same July day in 1961, Engine No. 487 was also found with its plow. However donning only one marker light, it was probably not heading out anytime soon. (Photograph by Alfred Jaeger.)

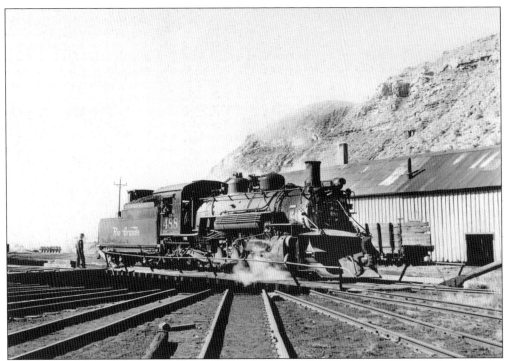

The turntable at Durango was small compared to those at many other Rio Grande facilities. As a result, a careful eye was kept when turning some of the larger locomotives like Engine No. 488.

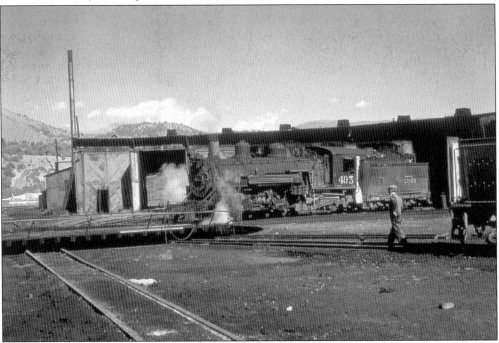

By October 1959, the summer runs of *The Silverton* had ended, but freight was still moving in Durango. Rio Grande conductor Roland Parsons has one hand to get a shot of Engine No. 495 on its way to work. (Photograph by Roland Parsons.)

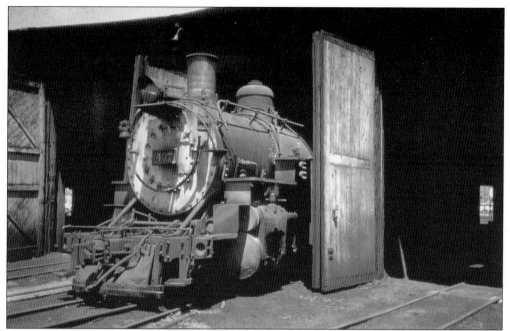

In the mid-1950s, the Rio Grande made a rare move, and instead of the narrow-gauged Monarch Branch being scrapped, it was converted to standard gauge. No longer needed at Salida, the orphaned power was moved to Durango and other parts of the narrow gauge, giving new life to engines like No. 497.

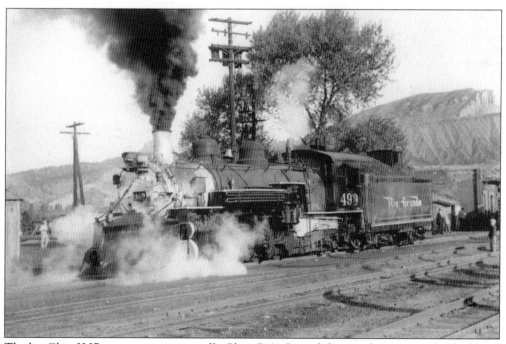

The big Class K-37 engines were originally Class C-41 Consolidations that years earlier had been converted from standard to narrow gauge. This 1955 photograph shows Engine No. 499 in the Durango yards.

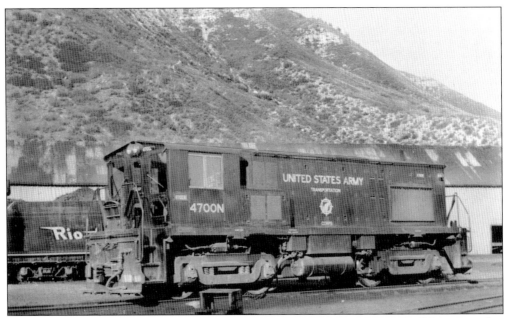

Dubbed the "Little Monster" by steam-loving rail fans, the U.S. Army's No. 4700N is pictured in Durango in June 1955. The new diesel, leased for test purposes, acted as a switcher in Durango and handled freights to Farmington and Chama.

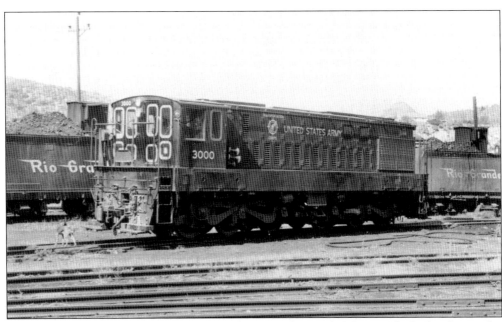

Much to the dismay of steam-locomotive enthusiasts, the "Little Monster" had a brother, and it too would work the narrow gauge. In this photograph, U.S. Army No. 3000 sits in the Durango yards in September 1959.

Eight

I'VE BEEN WORKIN' ON THE RAILROAD

Periodic stops along their route allowed opportunity for maintenance by the crews. In this photograph, engineer Dunsmore and fireman Deickman see that Engine No. 477 gets a little oil.

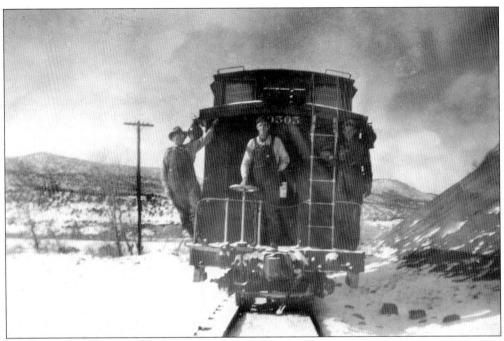

On their way to Durango, Conductor Bruce, Brakeman Blackstone, and another unidentified crewman pose for the camera on the back of Caboose No. 0505.

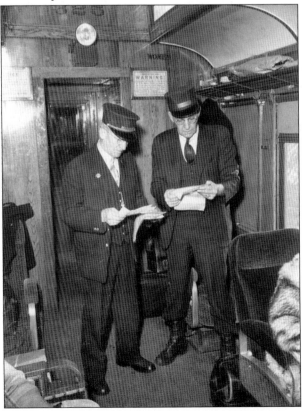

Keeping *The Silverton* on time and its passengers safe was often the responsibility of longtime Rio Grande employee Al Lyons. After a brief stop in Animas Canyon, this photograph shows conductor Lyons engaged in rounding up rail fans so his train can depart.

Some old steam locomotive engineers believed that every engine had its own feel and that the secret to being a good engineer was to know the locomotive. This photograph shows a narrow-gauge veteran at the throttle of one of the Rio Grande's Class K-28s.

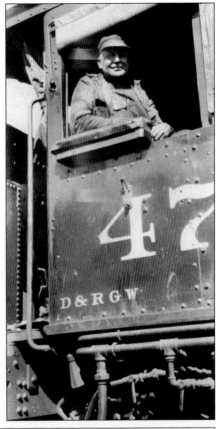

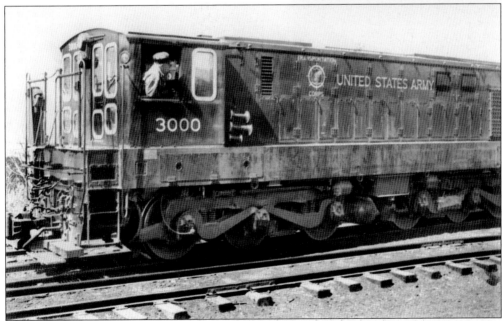

In the late 1950s, John Deickman proved that old engineers could be taught a few new tricks. He is pictured here in the cab of the U.S. Army's No. 3000 learning the ways of the diesel.

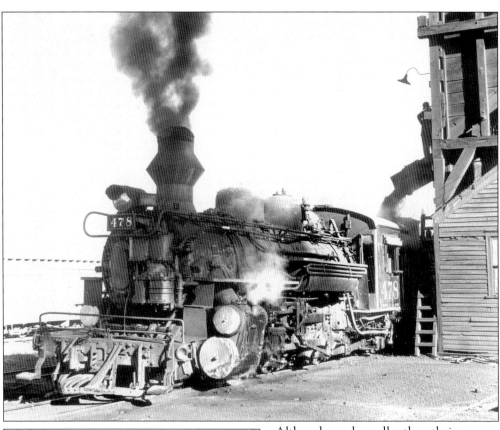

Although much smaller than their standard-gauge counterparts, it still took a lot of coal to keep narrow-gauge engines running. In this photograph, a crewman stands on the Durango coal dock as he fills the tender of Engine No. 478.

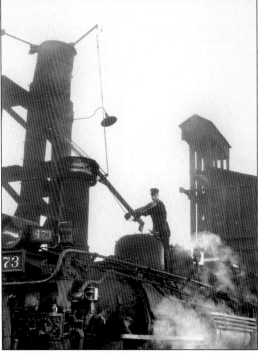

The sand tower and the traction it provided played a vital role in proper locomotive operation. Silhouetted against the clear Durango sky, this crewman tends to the sand dome of Engine No. 473.

While on the road, the conductors and brakemen often had a unique view of their trip. This scene was taken from the cupola of Caboose No. 0505 on a Durango-bound freight.

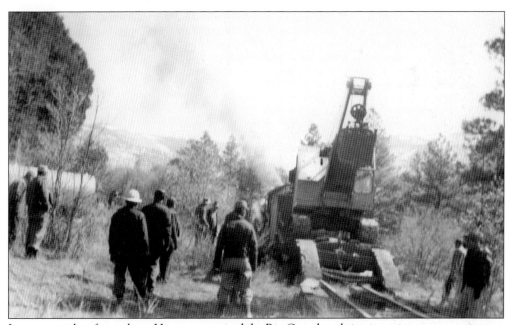
Its remote right-of-way above Hermosa required the Rio Grande to bring in maintenance equipment by rail. In 1948, bulldozers were brought in to do grade work.

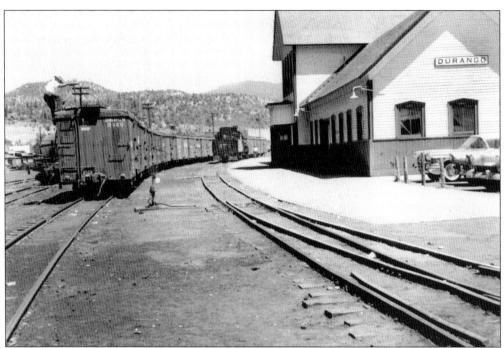

During the late 1950s, increased freight traffic between Alamosa and Farmington saw additional shipments through Durango. In preparing for the next train, a yardman sets the brake on a boxcar.

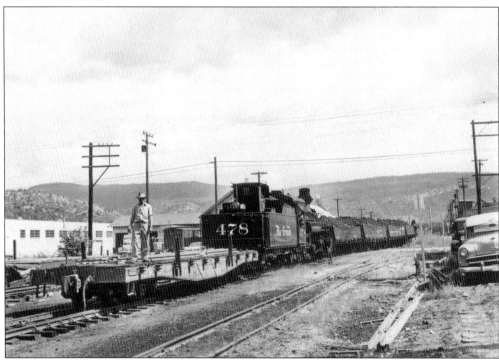

Switching duties around Durango included movements within the yards and along the right-of-way through town. This crew is pictured spotting a coal delivery near Eighth Street.

Railroading in Durango was an interactive experience for passengers riding the narrow gauge. In this photograph, several anxious rail fans converse with the crew of *The Silverton*, including venerable conductor Al Lyons.

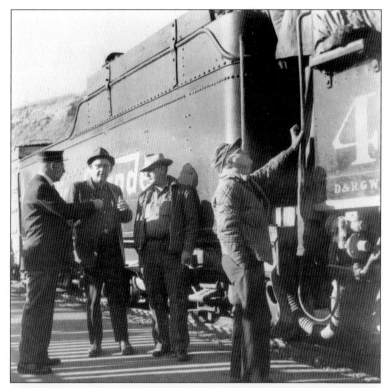

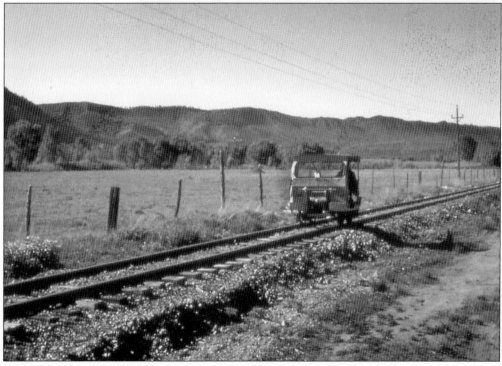

During the dry season, burning cinders could easily start a fire along the right-of-way. Track crews in motorcars often ran behind trains to prevent such occurrences.

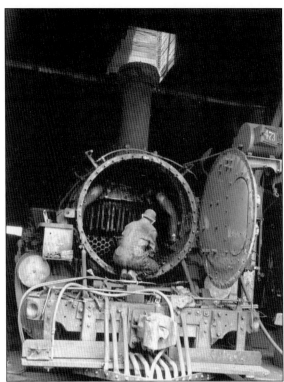

The K-28s saw a great deal of service and required a lot of maintenance. In this photograph, a member of the Durango shop crew prepares to do some flue work.

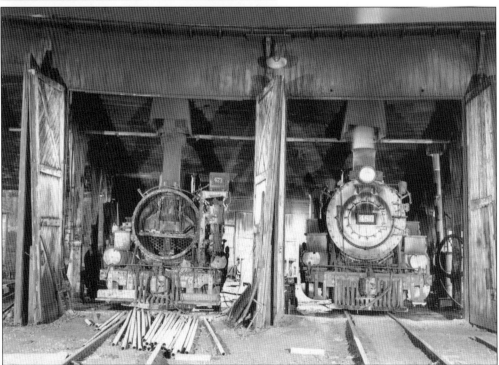

Night has come in the scene above, and replacement flues litter the ground. With Engine No. 480 bedded down beside it, No. 473 awaits morning and further repairs.

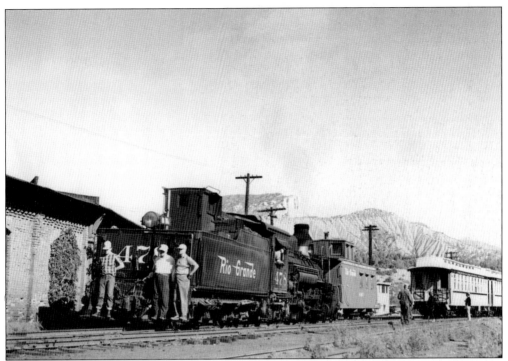

Several yard employees catch a ride on the back of Engine No. 478 as it moves past the Durango roundhouse. This image provides a good view of the "doghouse" on top of the tender.

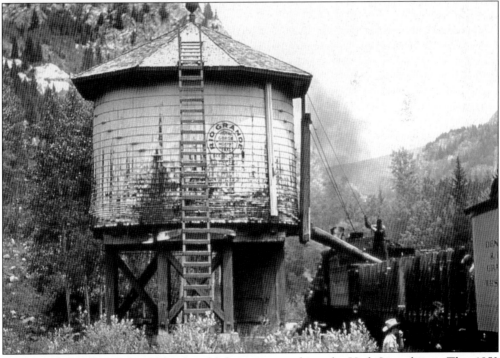

Working the grade north was hard and left engines working the High Line thirsty. This 1953 photograph shows *The Silverton* stopping for a drink.

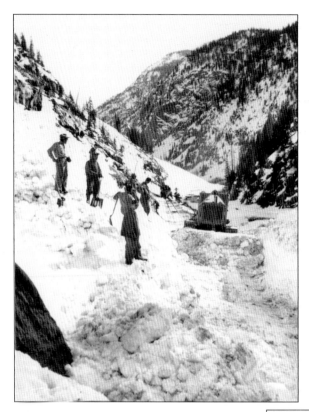

Trains on the Silverton Branch operated in all types of weather, as did the track crews. This 1948 photograph shows a group of laborers watching a bulldozer work in Animas Canyon. (Photograph by M. R. Henry.)

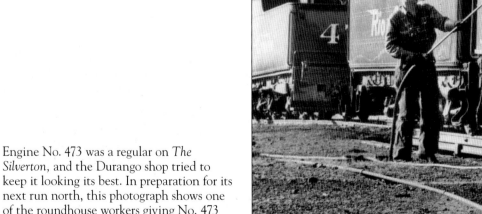

Engine No. 473 was a regular on *The Silverton*, and the Durango shop tried to keep it looking its best. In preparation for its next run north, this photograph shows one of the roundhouse workers giving No. 473 a bath.

Nine

REVIVAL AND RENAISSANCE

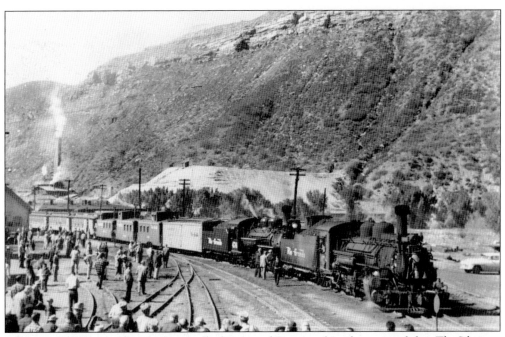

By the early 1950s, rail fans had not only discovered Durango but also ensured that *The Silverton* often left the depot with a sold-out crowd. This doubleheader included Engines No. 478 and No. 476 and a few "cabeese" that were being employed as coaches.

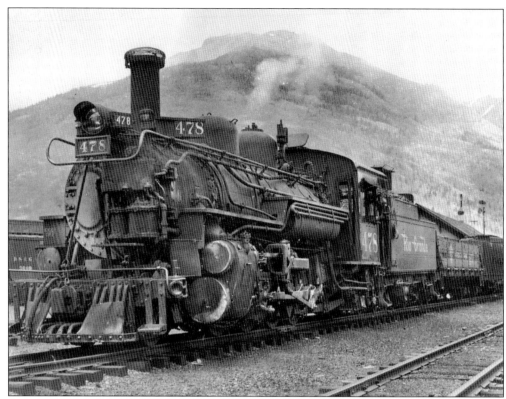

America's involvement in World War II was at its height when this shot was taken in Silverton. Despite gas rationing and a short supply of camera film, rail fans still managed to get out and photograph the narrow gauge.

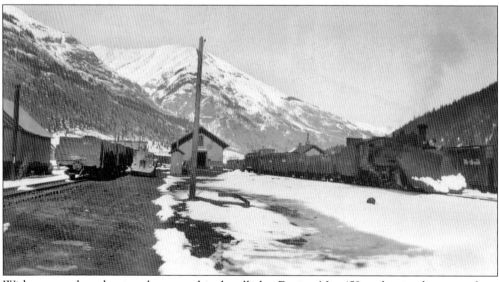

With a snowplow that nearly covered its headlight, Engine No. 453 makes its departure from Silverton in March 1946. On the rear is the proverbial mixed combine, which starting that summer handled a growing number of rail fans.

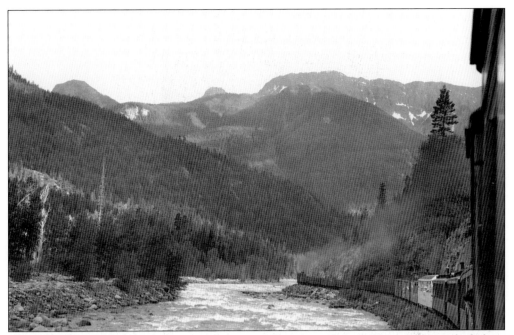

The mixed train to Silverton was not always a small consist. This 1950 view shows a fairly long train moving through the Animas Canyon, including a number of freight cars, the *Silver Vista*, and a string of coaches.

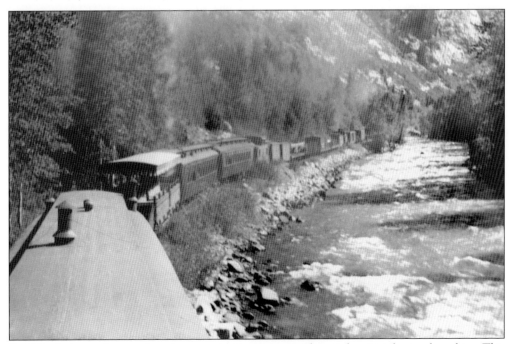

By 1951, the increasing number of summer passengers required more than just the usual combine. This photograph shows several coaches in use, as well as the open gondola used for the "overflow."

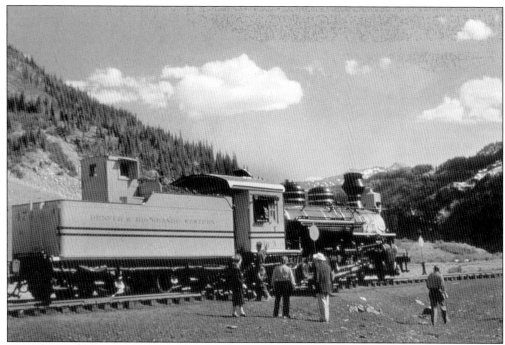

The yellow and black "bumblebee" paint scheme was popularized by Engine No. 268 at the 1949 Chicago Railroad Fair. It was such a success that Rio Grande management applied it to Engine No. 473 in the early 1950s.

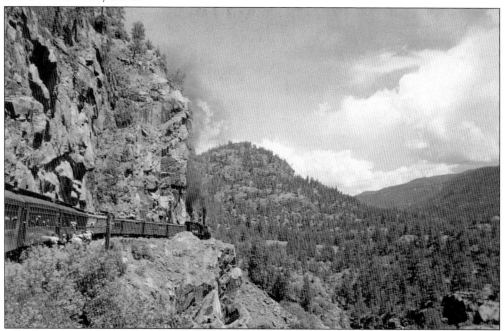

Several of the regular coaches on *The Silverton* got a coat of yellow and black and earned the "painted train" name. However so many people were discovering the narrow gauge that the railroad was having difficulties in providing enough coaches. This photograph, taken at a stop on the High Line, shows coaches in Grande Gold as well as those still wearing San Juan green.

As the passenger trips to Silverton became more popular, the Rio Grande decided to indulge the traveling public and built the glass-enclosed *Silver Vista*. This advertising broadside touts the Sunday, Wednesday, and Friday excursions via *The Silverton* and its celebrated sightseeing car.

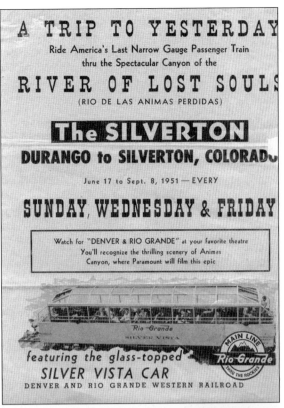

A TRIP TO YESTERDAY

Ride America's Last Narrow Gauge Passenger Train
thru the Spectacular Canyon of the

RIVER OF LOST SOULS

(RIO DE LAS ANIMAS PERDIDAS)

The SILVERTON

DURANGO to SILVERTON, COLORADO

June 17 to Sept. 8, 1951 — EVERY

SUNDAY, WEDNESDAY & FRIDAY

Watch for "DENVER & RIO GRANDE" at your favorite theatre
You'll recognize the thrilling scenery of Animas
Canyon, where Paramount will film this epic

featuring the glass-topped
SILVER VISTA CAR
DENVER AND RIO GRANDE WESTERN RAILROAD

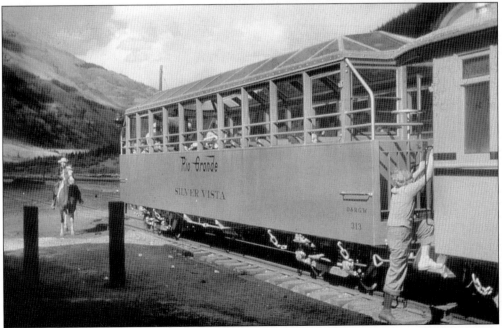

Rarely referred to as Coach No. 313, the *Silver Vista* is pictured at Silverton in 1951. In a scene that might have been reminiscent 50 years earlier, a horse and rider have come down to the depot to greet the train.

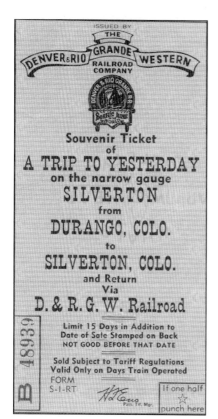

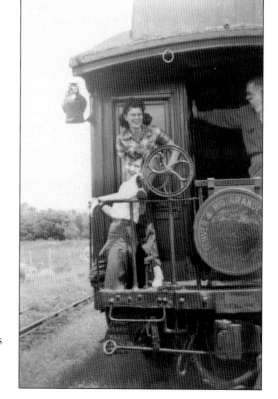

This 1955 ticket, and many more like them, helped keep the railroad running. From the late 1940s through the 1960s, rail fans came to the rescue of the narrow gauge and helped keep *The Silverton* alive.

By 1950, the opportunities for scenes like this happy gathering on the back of the *Alamosa* were coming to an end. Soon the *San Juan* would become a thing of the past.

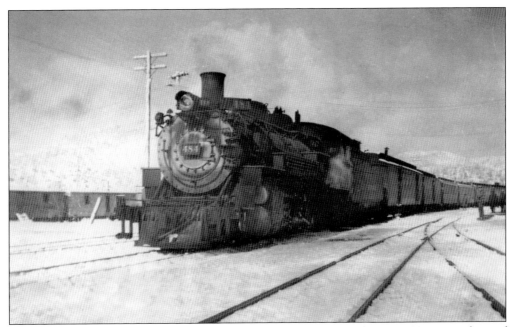

History was made on January 31, 1951, when the *San Juan* made its last run. Waiting in front of the Durango depot, Engine No. 484 prepares to leave for Alamosa.

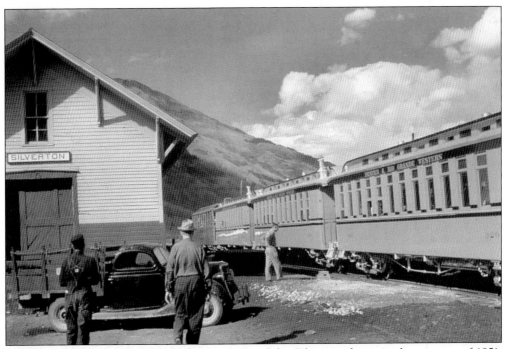

A portion of the "painted train" waits in front of the Silverton depot in the summer of 1951. The two-stripe pattern on Coach No. 320 did not last long. In a few years, the Silverton coaches would be painted with one black stripe.

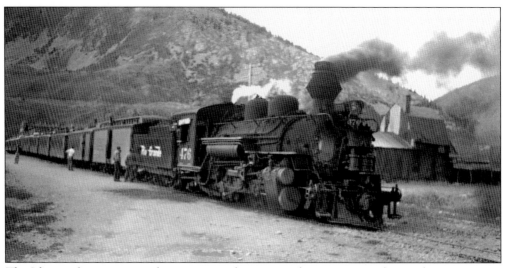

The Silverton has just arrived at its namesake as several passengers and crew discuss narrow-gauge operations. The railroad had installed a diamond stack to Engine No. 476 to give it a more vintage appearance.

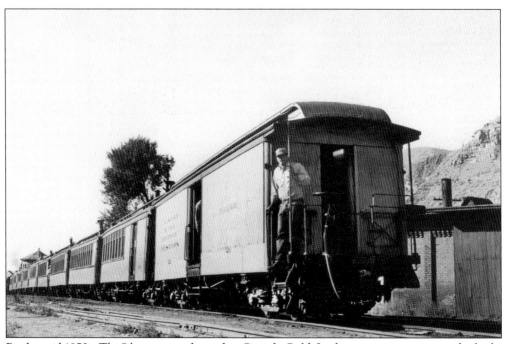

By the mid-1950s, *The Silverton* was dressed in Grande Gold. In this scene, an anxious rider looks out from Baggage Car No. 126, waiting for the engine that will take the train north.

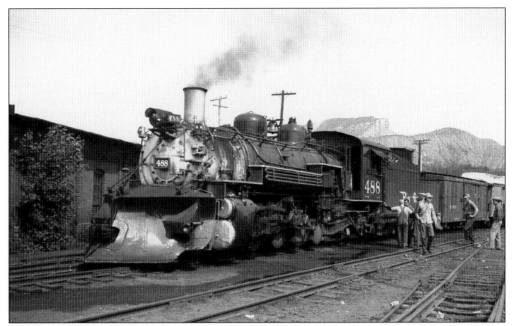

For those not lucky enough to have a ticket on *The Silverton*, there were other sights to see around the Durango yards. In this scene, a couple of photographers survey Engine No. 488, while another talks with one of the crew.

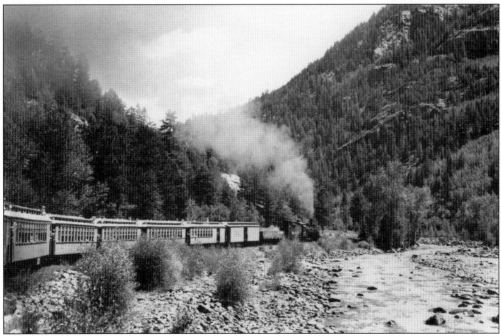

With the demise of the *San Juan*, some of its cars were given a coat of Grande Gold and joined the "painted train." It often required every coach in the yard to accommodate trains this size.

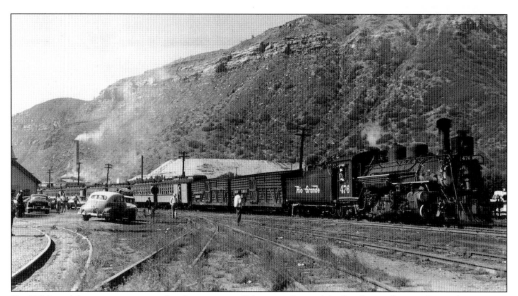

By 1954, rail fans wanting to take the train to Silverton hoped for both a ticket and a parking spot. Like some of the other "sports models," Engine No. 476 retained its electric headlight encased in a fake oil lamp for a more vintage appearance.

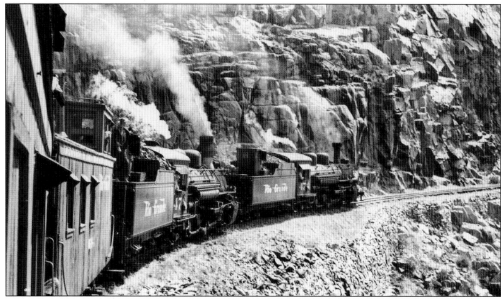

This photograph of Class K-27 Engines No. 476 and 478 doubleheading *The Silverton* was taken on the High Line in the 1950s. Despite the smoke and cinders, this was still the best seat in the house for a rail fan.

Ten

NARROW GAUGE IN THE MODERN ERA

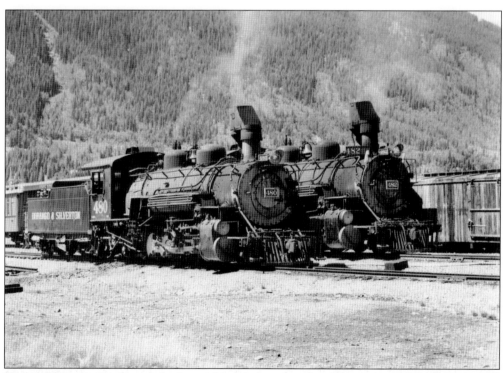

By the 1980s, the Rio Grande had passed into private hands and was renamed the Durango and Silverton Narrow Gauge Railroad. Running on an upgraded right-of-way and expanded schedule, twin K-36's No. 480 and No. 482, now wearing D&SNG paint, stand side by side in Silverton. (Photograph by Allan C. Lewis.)

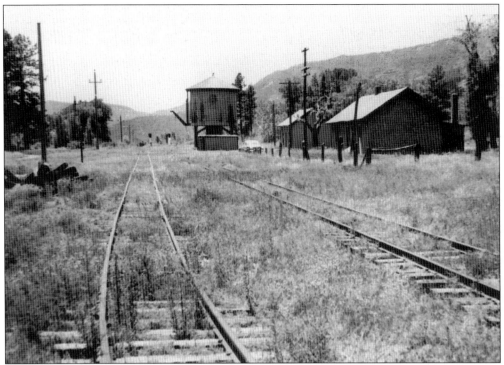

For many years, the management of the Rio Grande neglected the struggling Silverton Branch, hoping that decision makers would find it much easier to abandon dilapidated track. This 1958 photograph at Hermosa shows the results of deferred maintenance and a right-of-way that was long on weeds and short on ballast.

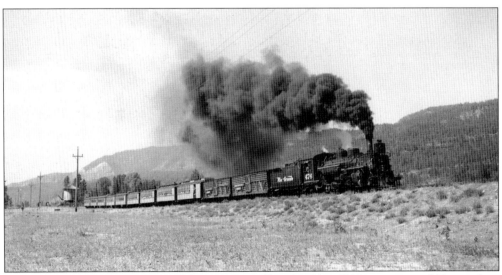

After the relatively flat confines of the Animas Valley, the Class K-28 engines would begin their uphill climb near Hermosa. The resulting plumes of smoke from the hard-working engines made Hermosa a popular stop for photographers chasing *The Silverton*.

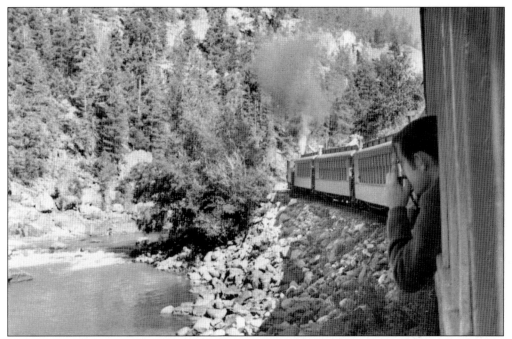

The train to Silverton continued to enjoy heavy patronage throughout the 1960s. In a scene that was duplicated by thousands of rail fans before him, this 1968 passenger and his camera try to get a better angle on the narrow-gauge experience.

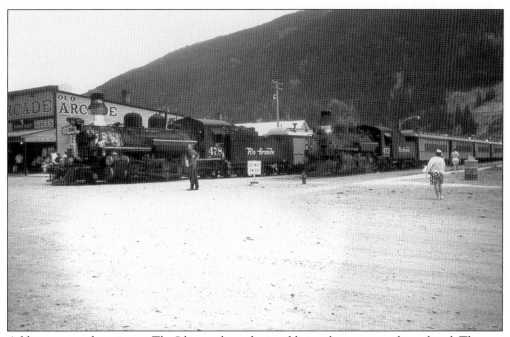

Adding a second section to *The Silverton* brought in additional revenue to the railroad. The two engines and their passengers were a welcome sight to Silverton merchants as well.

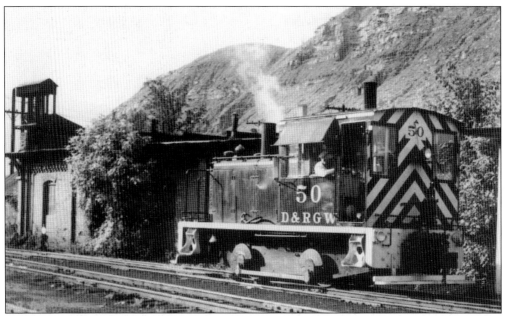

Although rail fans had mixed feelings about Durango's previous attempts at dieselization, No. 50 was given a warmer reception and earned its keep as a yard switcher. The little Davenport engine was purchased in 1963 and had a 200-horsepower Caterpillar engine.

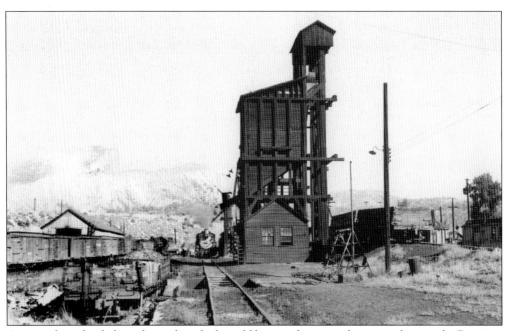

A pinnacle in the skyline, the coaling dock could be seen from just about anywhere in the Durango yards. However once freight service was abandoned over Cumbres Pass, the Rio Grande felt the structure had outlived its usefulness, and it was torn down in the late 1960s.

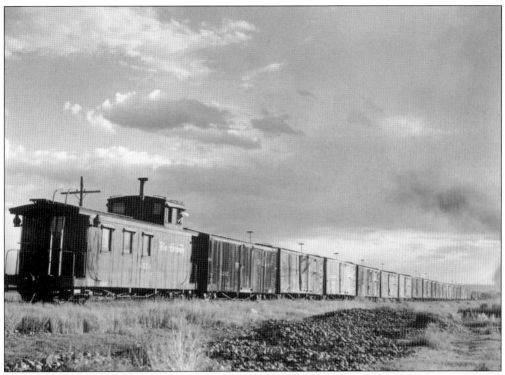

The unexpected freight boom in Farmington was not to last forever. This prophetic image, taken in 1961, captures a Durango-bound train heading off into the sunset, a precursor of the demise of narrow-gauge freight service.

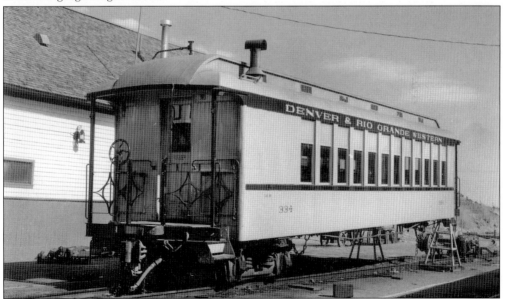

By the early 1970s, abandonment of the Farmington Branch and the tracks to Chama had isolated Durango. As a result, many of the maintenance activities that might once have been performed in Alamosa were now the responsibility of the Durango shops. This interesting 1976 view demonstrates the repairs being made to the trucks of Coach No. 330.

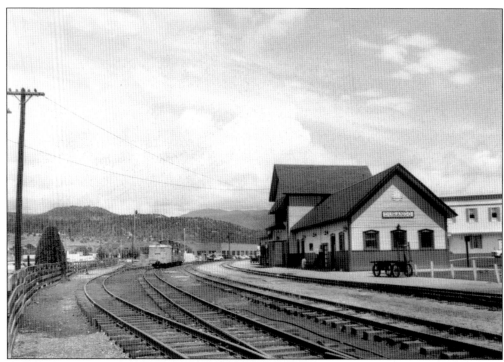

In the 1960s, the Durango depot and the equally old Palace Hotel behind it both received a new coat of paint. Another improvement for rail fans was an expanded parking lot on the west side of the tracks.

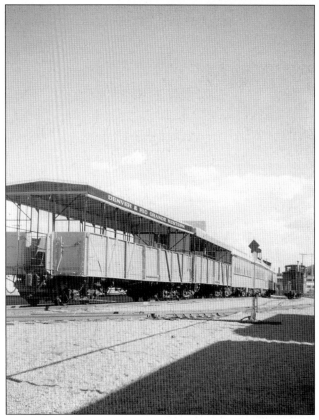

With many of its older coaches scrapped or sold off, the Rio Grande dipped into its fleet of obsolete freight cars to meet the added demands of *The Silverton*. By 1964, this need was met through the introduction of the 400 Series open cars, which afforded passengers the smell of the smoke and a more unobstructed view of the scenery.

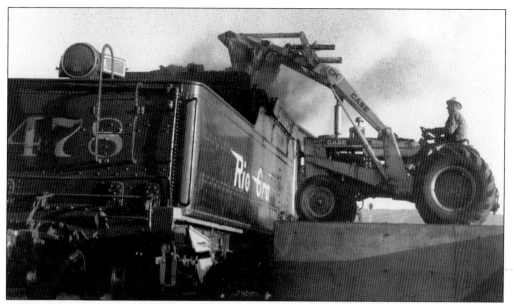

With its coaling tower razed, Durango engine crews were now faced with the dilemma of how to top of its hungry tenders. This 1971 photograph shows a front-end loader filling the coal bunker of Engine No. 478.

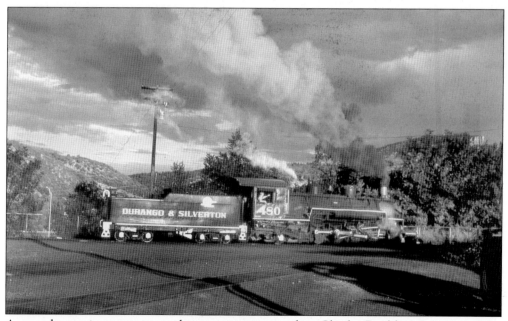

A new chapter in narrow-gauge history was written when Charles Bradshaw Jr. acquired the Silverton Branch from the Rio Grande in 1981. Looking to blend efficiency with profits, the new Durango and Silverton Narrow Gauge Railroad sought to make lasting improvements. One of these upgrades was the mechanical resurrection of Class K-36 Engine No. 480.

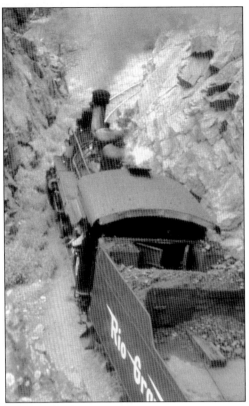

The three Class K-28 engines were handling all the tonnage they could, but the larger Class K-36s and K-37s were sitting idle because of clearance issues above Rockwood. Meeting this challenge, Durango and Silverton crews began a program of rebuilding and reinforcing many of the bridges and widening rock cuts, like the one in this photograph.

The operations of Class K-36 and K-37 engines were a treat for rail fans, but larger power meant longer trains and much-needed revenue for the railroad. Once the right-of-way improvements had been made, engines like No. 481 and their expanded consists had full reign over the length of the system. (Photograph by Allan C. Lewis.)

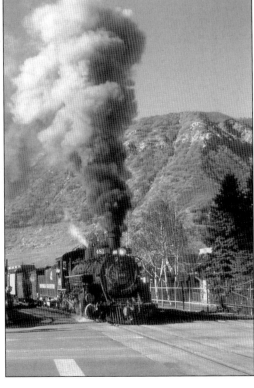

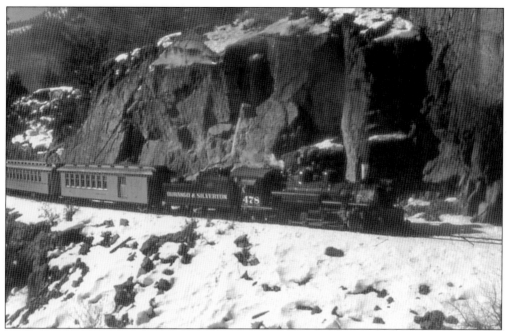

Although tourist season was a favorite for Durango merchants, the Durango & Silverton was anxious to prove to the traveling public that it was a viable option in the winter as well. The "snow train" offered passengers a glimpse of the Animas winter and provided photographers with an amazing backdrop.

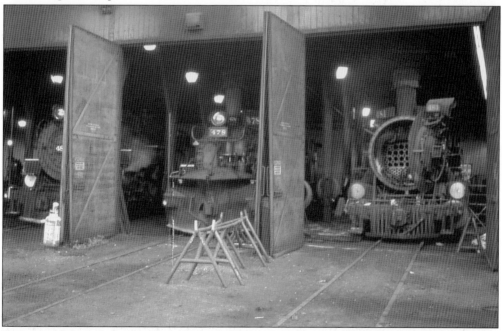

Fate can often douse even the brightest of dreams, and such was the case in 1989 when the 100-year-old Durango roundhouse was destroyed by fire. The engines were restored, and another roundhouse was soon built with new shops that are well equipped to handle the needs of the railroad.

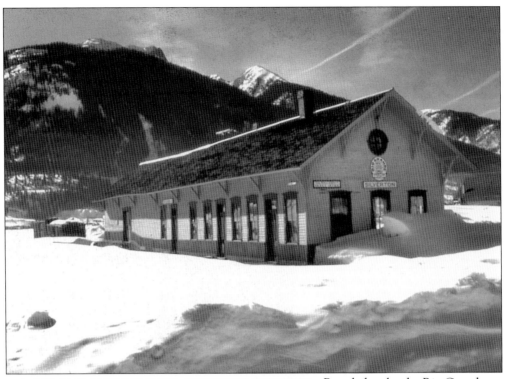

Boarded up by the Rio Grande, and later blown up by a disgruntled citizen, the Silverton depot was acquired by the D&SNG in 1985. As winter set in a year later, the depot was seen in a shroud of white, with snowdrifts coming up to the windows.

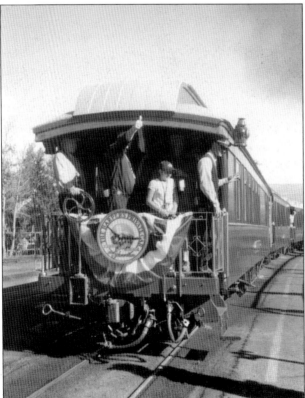

The Bradshaw era lasted for 16 years. In 1997, the D&SNG passed into the capable hands of Allen Harper. His appreciation of the narrow gauge has been a blessing to rail fans, and many improvements and attractions have been added during his administration. In this 2003 photograph, Harper gives the "thumbs-up" as the *Presidential Special* prepares to leave Durango. (Photograph by Allan C. Lewis.)

The 1930s-era rail buses used on the Rio Grande Southern were affectionately known as Galloping Geese. Surviving the demise of the RGS, Goose No. 4 was restored to operating condition and delighted rail fans at Durango's first annual Railfest in 1998. (Photograph by Allan C. Lewis.)

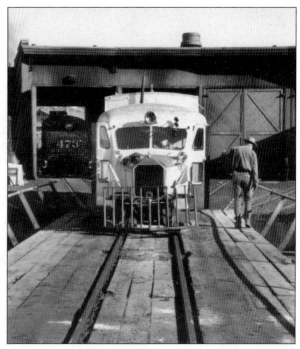

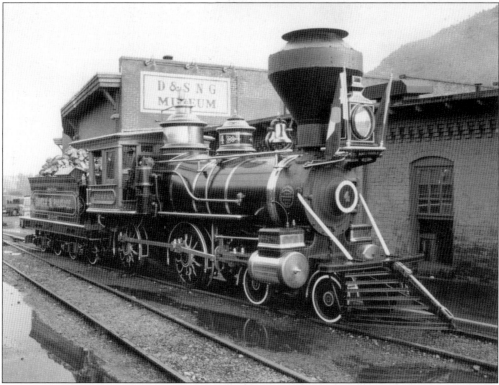

Another main attraction for Railfest is the Eureka & Palisades Engine No. 4, more popularly known to rail fans as the "Eureka." The vintage 1875 wood burner is pictured in all its glory in front of the D&SNG roundhouse and museum in 2004. (Photograph by Allan C. Lewis.)

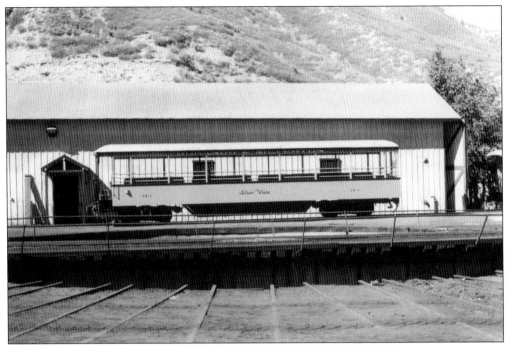

Fifty years after the original *Silver Vista* was destroyed in an Alamosa fire, a new open car bearing the same name was placed in service on the D&SNG. As of this writing (2006), the railroad has a plan to build a more accurate version of this famous coach. (Photograph by Doug Summer.)

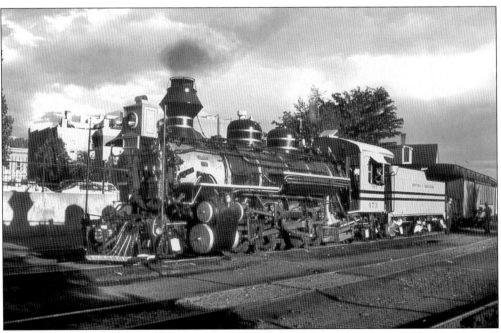

Some Durango railroad scenes are timeless. In 2005, the D&SNG returned Engine No. 473 to the familiar two-stripe bumblebee paint scheme worn in the 1950s. (Photograph by Allan C. Lewis.)

The nostalgia of the bygone era of railroading attracts local residents in period costume. Here a Durango saloon girl waves to departing passengers, urging them to "come back and see her sometime." (Photograph by Allan C. Lewis.)

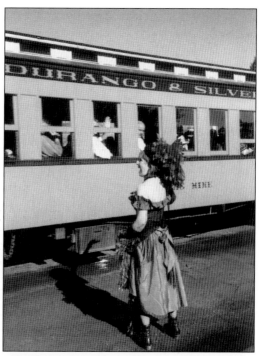

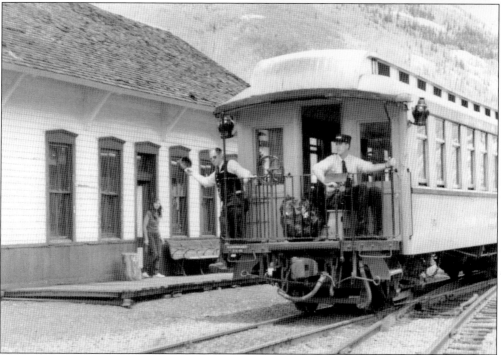

When visiting Durango, rail fans are still able to ride 100-year-old locomotives and passenger cars through some of the most beautiful landscape in the country. However safety still comes first on the D&SNG. The equipment used has been mechanically modernized and crews like this one have the highest concern for the safety and comfort of their passengers. (Photograph by Allan C. Lewis.)

ACROSS AMERICA, PEOPLE ARE DISCOVERING SOMETHING WONDERFUL. *THEIR HERITAGE.*

Arcadia Publishing is the leading local history publisher in the United States. With more than 3,000 titles in print and hundreds of new titles released every year, Arcadia has extensive specialized experience chronicling the history of communities and celebrating America's hidden stories, bringing to life the people, places, and events from the past. To discover the history of other communities across the nation, please visit:

www.arcadiapublishing.com

Customized search tools allow you to find regional history books about the town where you grew up, the cities where your friends and family live, the town where your parents met, or even that retirement spot you've been dreaming about.